**FEDERICO ZERI** (Rome, 1921-1998), eminent art historian and critic, was vice-president of the National Council for Cultural and Environmental Treasures from 1993. Member of the Académie des Beaux-Arts in Paris, he was decorated with the Legion of Honor by the French government. Author of numerous artistic and literary publications; among the most well-known: *Pittura e controriforma*, the Catalogue of Italian Painters in the Metropolitan Museum of New York and the Walters Gallery of Baltimore, and the book *Confesso che ho sbagliato*.

## Work edited by FEDERICO ZERI

**Text**
based on the interviews between
FEDERICO ZERI and MARCO DOLCETTA

This edition is published for North America in 1999 by NDE Publishing*

**Chief Editor of 1999 English Language Edition**
ELENA MAZOUR (*NDE Publishing**)

**English Translation**
PAUL METCALFE FOR SCRIPTUM S.R.L.

**Realisation**
CONFUSIONE S.R.L., ROME

**Editing**
ISABELLA POMPEI

**Desktop Publishing**
SIMONA FERRI, KATHARINA GASTERSTADT

ISBN 1-55321-005-0

### Illustration references

**Alinari archives:** 20b, 23b.

**Bridgeman/Alinari archives:** 16-17, 30-31, 32, 33, 38l, 38-39, 44/II-IX, 45/I-XIV.

**Dufoto:** 4t.

**Luisa Ricciarini Agency:** 4-5, 12-13b, 15b, 26b, 40l, 42t, 43cr-b.

**Giraudon/Alinari archives:** 1, 2-3, 6, 7, 8-9, 9t-b, 10, 10-11, 12-13t, 13t, 14 14-15t-b, 15t, 18t, 19tl, 22-23, 23t, 26t, 26-27, 34t, 36-37, 44/V-VI, 45/IX, 46.

**RCS Libri Archives:** 2, 17, 25l-r, 28, 30t, 38r, 40-41, 44/III-VII-VIII-XII, 45/II-III-IV-V-VI-VII-VIII-XIII.

**R.D.:** 12, 13bl-br, 18b, 19bl-r, 20t, 21, 24l-r, 29l-r, 30b, 34b, 35t-b, 40t, 41t-b, 42b, 43t-cl, 44/I-IV-X-XI, 45/X-XI-XII

Printed and bound by Poligrafici Calderara S.p.A., Bologna, Italy

* a registred business style of NDE Canada Corp.
  18-30 Wertheim Court, Richmond Hill, Ontario
  L4B 1B9 Canada, tel. (905) 731-12 88

*The captions of the paintings contained in this volume include, beyond just the title of the work, the dating and location. In the cases where this data is missing, we are dealing with works of uncertain dating, or whose current whereabouts are not known. The titles of the works of the artist to whom this volume is dedicated are in blue and those of other artists are in red.*

# MANET
# LE DÉJEUNER SUR L'HERBE

"An affront to public morality" was how the imperial court described LE DÉJEUNER SUR L'HERBE. Manet's work was refused by the Salon of 1863 and the echoes of the scandal reverberated through late nine-

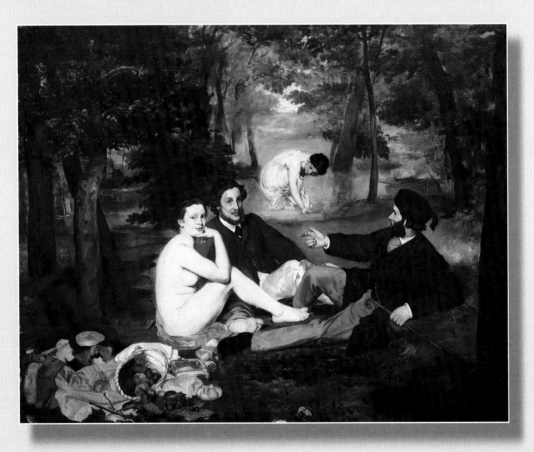

teenth-century Parisian society. The French master's revolutionary canvas broke through the barriers of academic painting and paved the way for the experimentation of modern art.

# THE BIRTH OF A SCANDAL

## LE DÉJEUNER SUR L'HERBE

*1862-1863*

Paris, Musée d'Orsay (oil on canvas, 208 x 264.5 cm)

● The idea for the work was first mooted in August 1862 at Argenteuil, when the painter, watching some women bathing in the Seine together with his close friend Antonin Proust, remarked, "It looks as if I'll have to do a nude. So be it. I'll do it in a transparent atmosphere and with figures like the ones we can see down there."

● The work was painted in 1863, and Manet had originally decided on a different title. It was submitted as *Le Bain* for the Salon of the same year and provoked indignant reactions on the part of the specialized critics and the official jury, who rejected it with no hesitation. Against the advice of his circle, the emperor Napoleon III then decided to ensure it an autonomous setting by creating an annex to the Salon, the celebrated *Salon des Refusés*.

● The subject unquestionably offended the moral sensibilities of the respectable bourgeoisie, who found the introduction of the erotic into the reassuring representation of their pastimes quite intolerable. In the setting of an ordinary picnic enjoyed by Parisians on an outing in the country, Manet placed the figure of a naked woman seated happily between two fully clothed young men. The second female figure, shown in the background clad in a negligee and delicately bending over the water, makes the nude in the foreground still more blatant.

◆ **EDOUARD MANET**
The decision to devote himself entirely to painting was a tormented one for the French master (1832-1883). Born into a family belonging to the solid Parisian bourgeoisie, his father being employed in the Ministry of Justice, the painter had to struggle for a long time to follow his vocation.

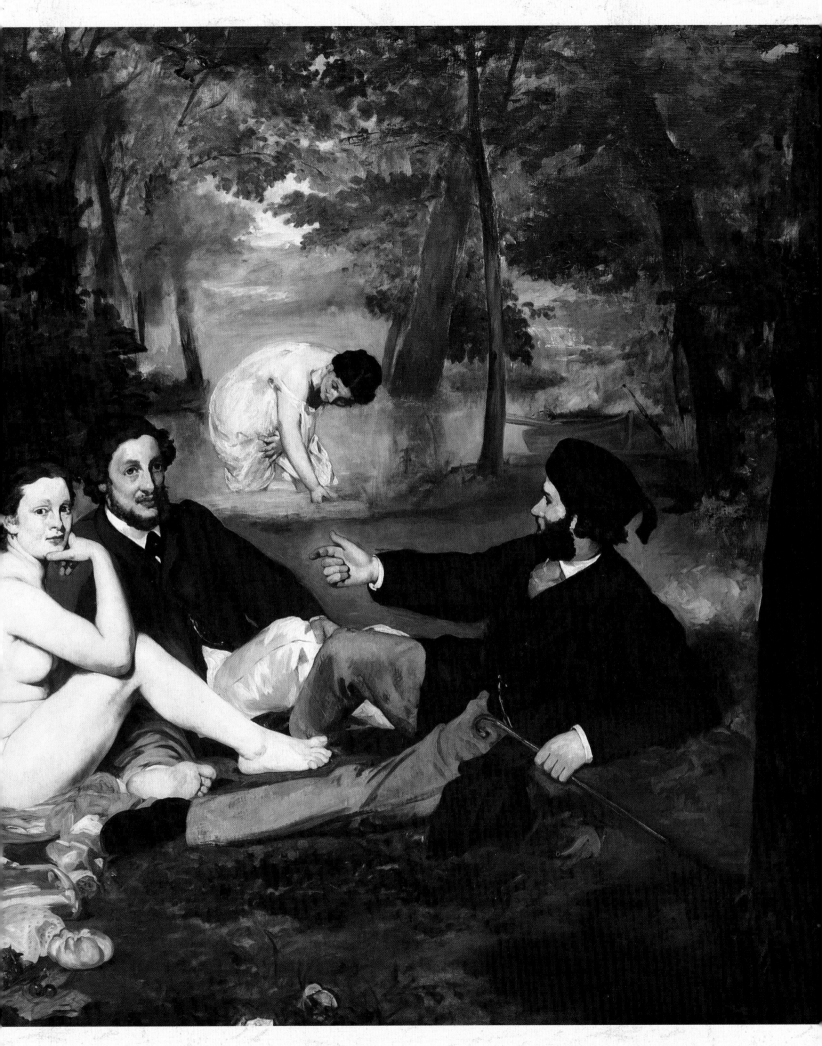

# A STATION FOR ART

L e Déjeuner sur l'herbe belonged to the collection of Etienne Moreau-Nélaton (1859-1927), the French painter and art historian. In 1906 he donated the painting, unquestionably the "historic' masterpiece of the collection, to the state. In addition to Edouard Manet's canvas, however, the splendid Moreau-Nélaton collection of one hundred works, now held in the Musée d'Orsay, also contains many other gems including the great nineteenth-century French masters from Corot to Delacroix, from Géricault to Daumier, and continuing up to the Impressionists.

◆ THE ORSAY MUSEUM (view of the great central concourse) Harmoniously adapting the architecture of the existing structure but leaving its glazed roof intact, the conversion of the station into a museum employs a terrace structure with the exhibits displayed on two levels.

*the painting:* LE DÉJEUNER SUR L'HERBE

● The present home of the collection was originally a railway station, designed in 1900 by the architect Victor Laloux in an attempt to centralize the Parisian rail system by locating its main hub in the very heart of the city. Industrial development soon made this plan obsolete, however, and the station fell into disuse.

● Abandoned by the French Railways in 1939, the building was used for various purposes over the years until plans were made in 1973 to turn it into a new museum of art for the second half of the nineteenth century. Ten years later, over the period 1984-1985, the Italian architect Gae Aulenti completed the internal refurbishment and display areas for the inauguration in 1986.

The original plans for the station drafted in 1900 envisaged a comfortable, luxurious structure to meet the sophisticated demands of the Parisians. Top left, the great clock of the central concourse. Above, plan of the main hall of the museum. Manet's work, marked in blue, is located at the entrance of the Moreau-Nélaton room.

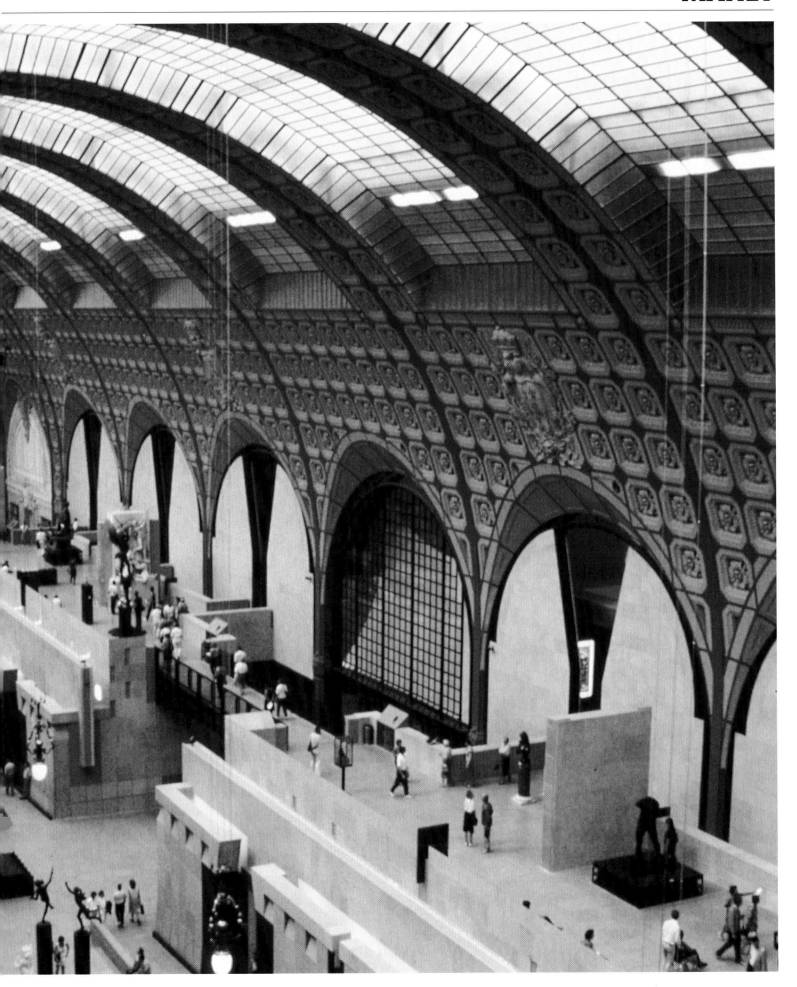

# COMPOSITIONAL STRUCTURE

The theme of *Le Déjeuner sur l'herbe* is not scandalous in itself, but the challenge to bourgeois morality is explicitly underscored by the painter. In the central group, the female nude, who faces the viewer almost with an air of complicity, contrasts violently with the natural pose of the two clothed men, engaged in pleasant conversation. Critics have generally recognized the female figure in the fore-

clad in a negligee bending over the water, which defines her sensuality. The compositional unity is completely shattered. The impression is of a great gap between the group of figures in the foreground and the background. The figures appear to pose in the reconstruction of a natural setting, like cut-outs on the stage of a theatre. The painting seems to disintegrate slowly into a sort of collage of different parts artificially held

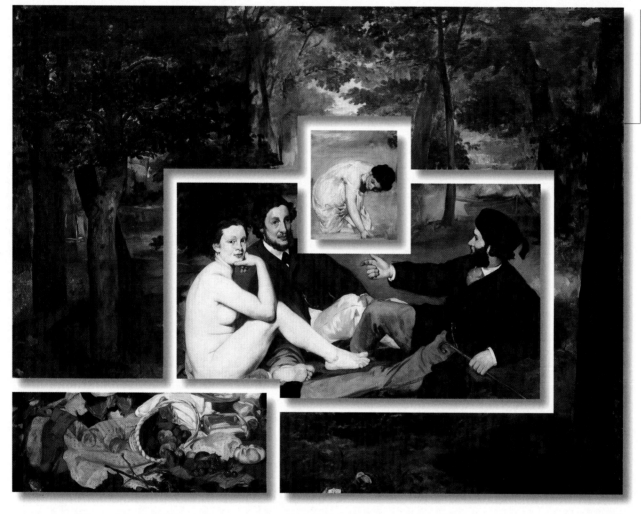

◆ VIOLATION OF PERCEPTUAL UNITY
The mosaic-like structure of the painting organizes it into three main units and directs the viewer's eye to the fragmented perusal of the individual parts. With this disjointed vision, Manet challenged the decorum of society during the Second Empire.

◆ YOUNG WOMAN IN A NEGLIGEE
The gracefulness and delicacy of the bather's gesture endow the figure with an intensely poetic character. She almost appears to be turning her profile towards the viewer and practically touching the hand of the figure in the foreground.

ground as Manet's model Victorine Meurent. The two gentlemen can be identified as the painter's brother Gustave, his hand outstretched in a conversational gesture, and his future brother-in-law, Ferdinand Leenhoff, with a distant, absorbed expression.

● In the left-hand corner, a still life formed by the woman's clothing and the picnic basket heightens the contrast of the situation. In the background, the perspective vista created by the succession of arboreal stage sets opens up on a young woman

together to form the image. It is as though Manet were observing and painting from two different viewpoints.

● The result was disconcerting and embarrassed contemporary society. It is useful to recall that the official Salon of 1863 saw the triumph of Alexandre Cabanel's *Birth of Venus*, subsequently purchased by Napoleon III, as an elegant and sophisticated painting far more in keeping with the tastes of the period. On the contrary, Manet eschewed allegory or idealization and abandoned the historical masquerades and mythological transpositions of academic painting.

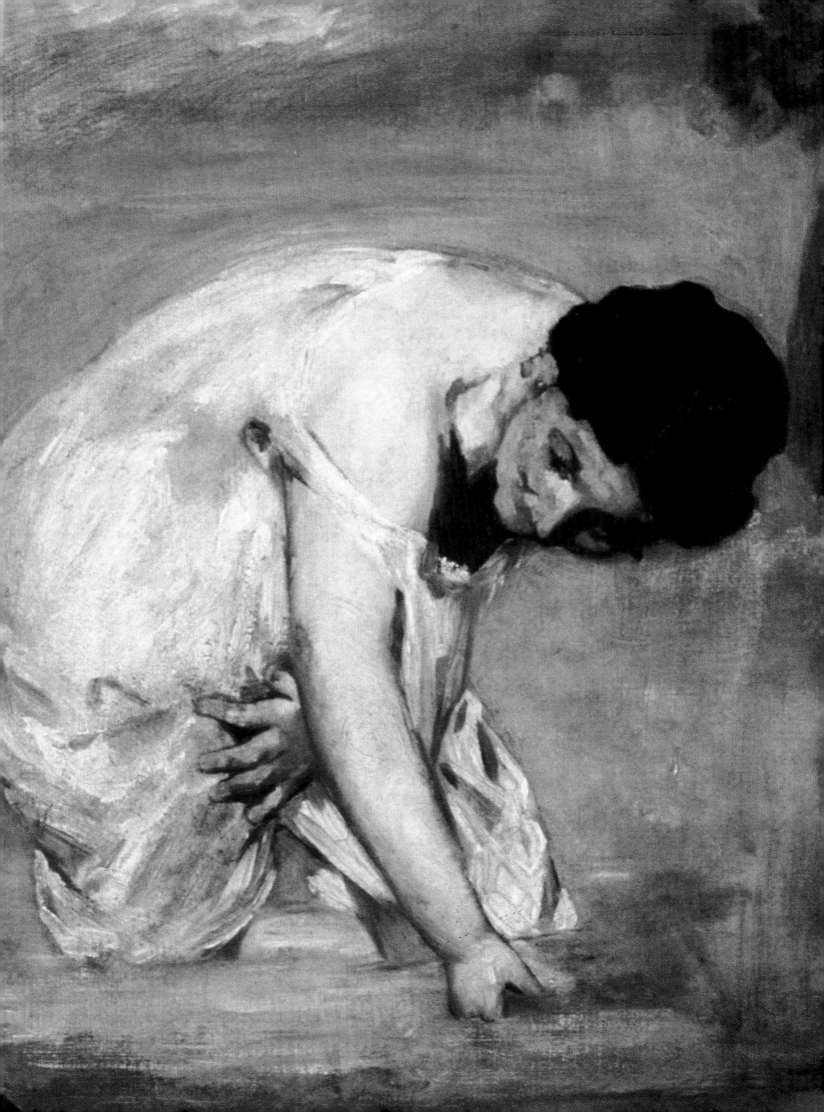

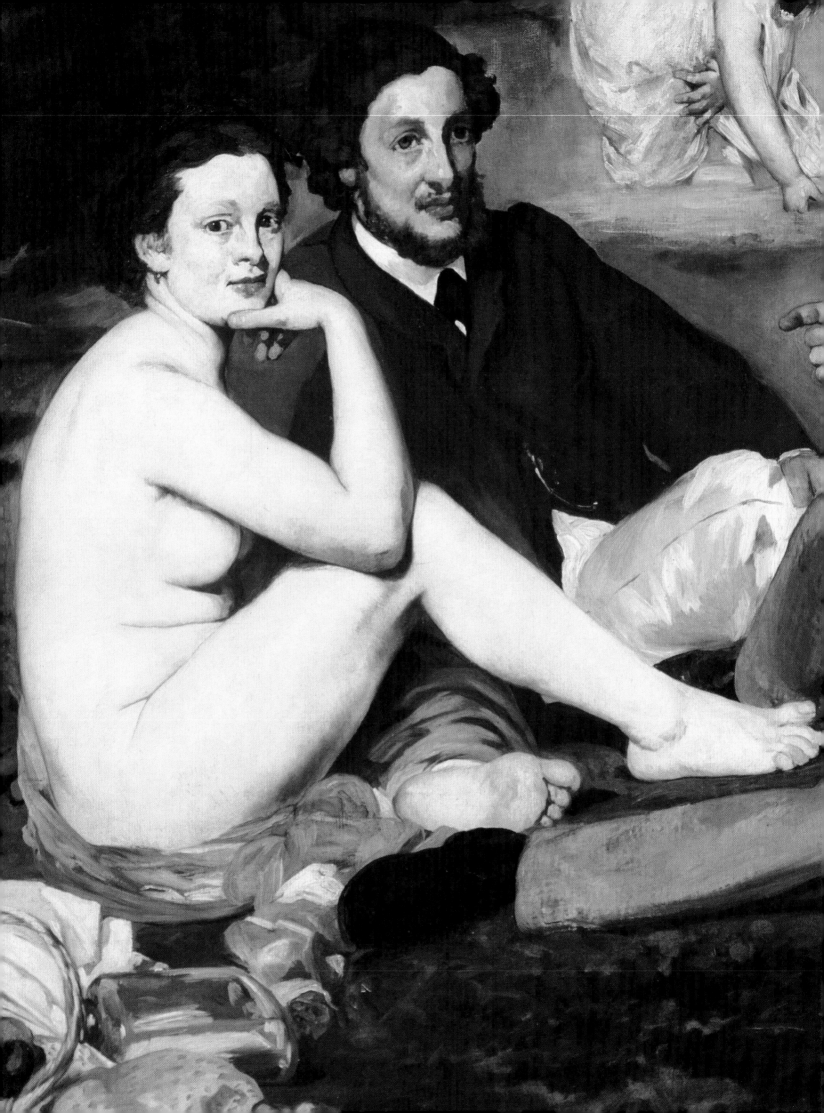

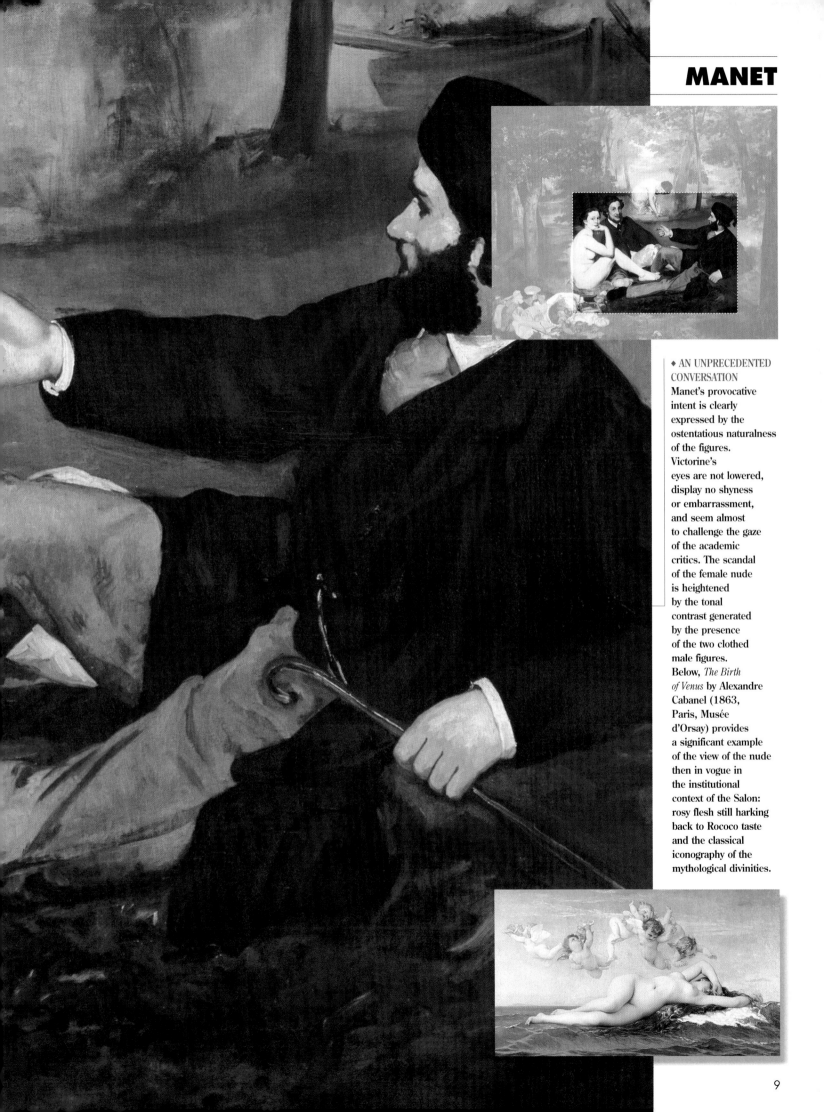

◆ AN UNPRECEDENTED
CONVERSATION
Manet's provocative
intent is clearly
expressed by the
ostentatious naturalness
of the figures.
Victorine's
eyes are not lowered,
display no shyness
or embarrassment,
and seem almost
to challenge the gaze
of the academic
critics. The scandal
of the female nude
is heightened
by the tonal
contrast generated
by the presence
of the two clothed
male figures.
Below, *The Birth
of Venus* by Alexandre
Cabanel (1863,
Paris, Musée
d'Orsay) provides
a significant example
of the view of the nude
then in vogue in
the institutional
context of the Salon:
rosy flesh still harking
back to Rococo taste
and the classical
iconography of the
mythological divinities.

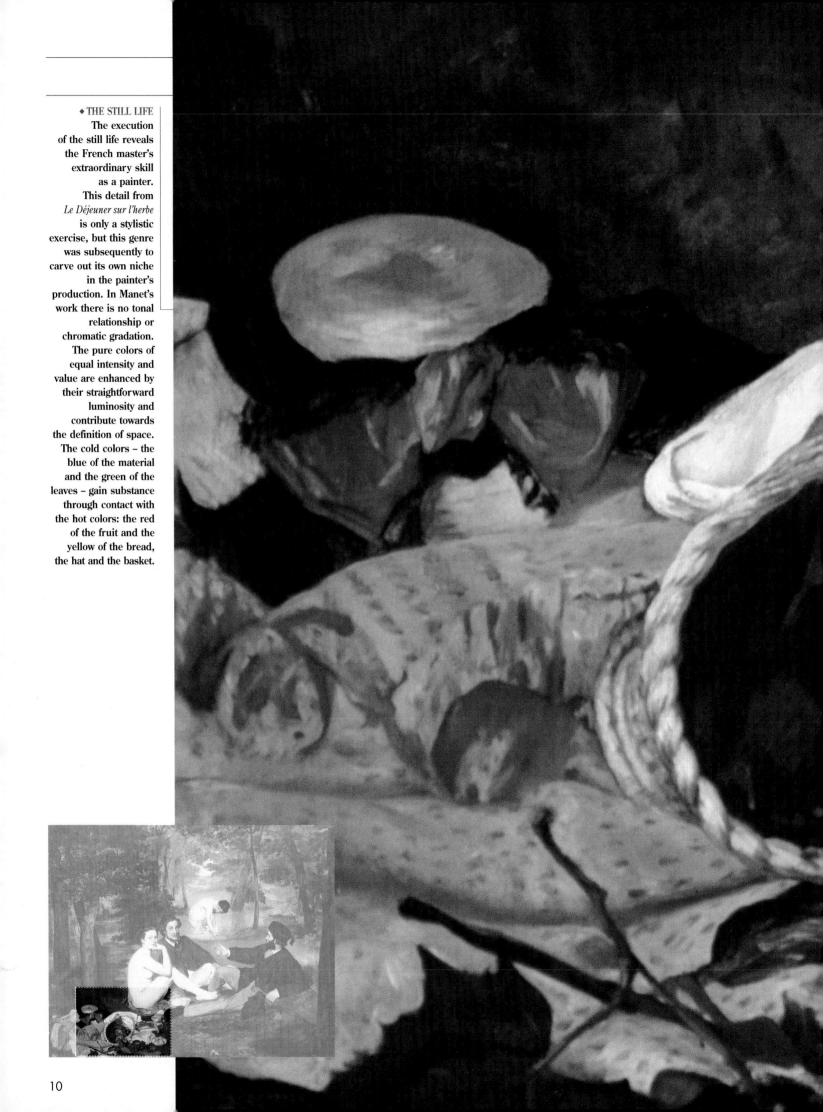

◆ THE STILL LIFE
The execution
of the still life reveals
the French master's
extraordinary skill
as a painter.
This detail from
*Le Déjeuner sur l'herbe*
is only a stylistic
exercise, but this genre
was subsequently to
carve out its own niche
in the painter's
production. In Manet's
work there is no tonal
relationship or
chromatic gradation.
The pure colors of
equal intensity and
value are enhanced by
their straightforward
luminosity and
contribute towards
the definition of space.
The cold colors – the
blue of the material
and the green of the
leaves – gain substance
through contact with
the hot colors: the red
of the fruit and the
yellow of the bread,
the hat and the basket.

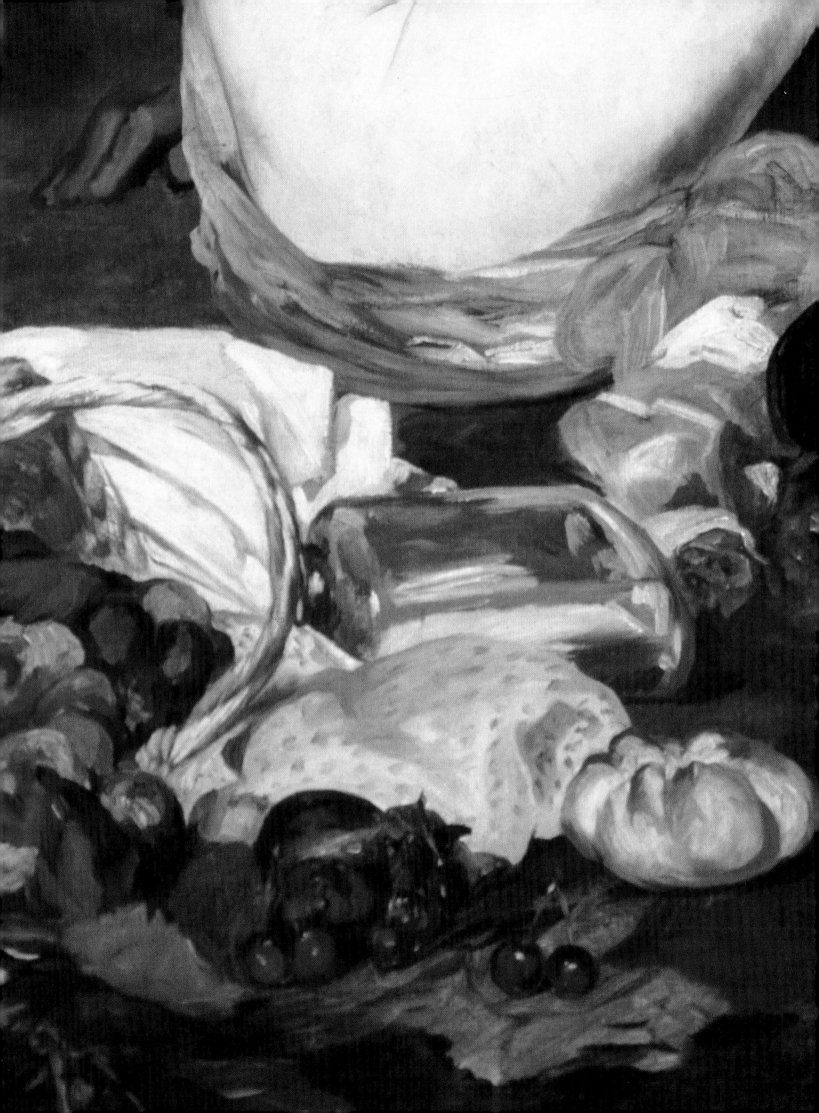

# A PASTORAL CONCERT

Picnics in the country, the dainty and decorous luncheons in the open that formed a recurrent theme in nineteenth-century art, provide the setting for the French master's work. Auguste Barthélemy Glaize's *Picnic* of 1850 exemplifies the expression of static poses characteristic of contemporary taste. Far from providing a precedent for interpretation of Manet's canvas, however, this painting belongs to the academic iconographic tradition supported by the culture of the Salon.

● Like every other art student and apprentice painter of his day, Edouard Manet trained at the Louvre by studying and copying the works of the great masters. In its execution and construction in the studio, *Le Déjeuner sur l'herbe* reveals a deep knowledge of the works of the past. The subject echoes that of Titian's *Pastoral Concert*, which presents an analogous arrangement of clothed and nude figures in the country. The central group seems to be a reworking of an engraving by Marcantonio Raimondi, a group of river gods taken from a *Judgement of Paris* by Raphael. Works inspired by the great classics of painting form a constant element in Manet's output. In developing the subject, he often sacrifices imagination to the extraordinary naturalness of his artistic talent, transforming and debunking the great classical compositions.

● Sensitive to the prompting of contemporary art, Manet also belongs to the disrespectful and often turbulent tradition of great realistic painting led by Gustave Courbet. Direct precedents of *Le Déjeuner sur l'herbe* can be found in Courbet's *Young Women on the Banks of the Seine* of 1857 and *The Bathers* of 1853. The poet Baudelaire called upon artists to "paint modern beauty". Courbet did so with violence, and Manet also contrived to do so, but with less vehemence and more composure, undermining the codes of traditional order from within, staging his revolution inside the walls of the Salon.

◆ MARCANTONIO RAIMONDI
*The Judgement of Paris*
(After Raphael, c. 1515-16, detail)
The ceramic oval from which this detail is taken represents a group of seated river gods. Manet appears to have copied the poses of Raimondi's figures exactly.

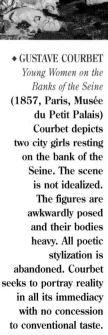

◆ GUSTAVE COURBET
*Young Women on the Banks of the Seine*
(1857, Paris, Musée du Petit Palais)
Courbet depicts two city girls resting on the bank of the Seine. The scene is not idealized. The figures are awkwardly posed and their bodies heavy. All poetic stylization is abandoned. Courbet seeks to portray reality in all its immediacy with no concession to conventional taste.

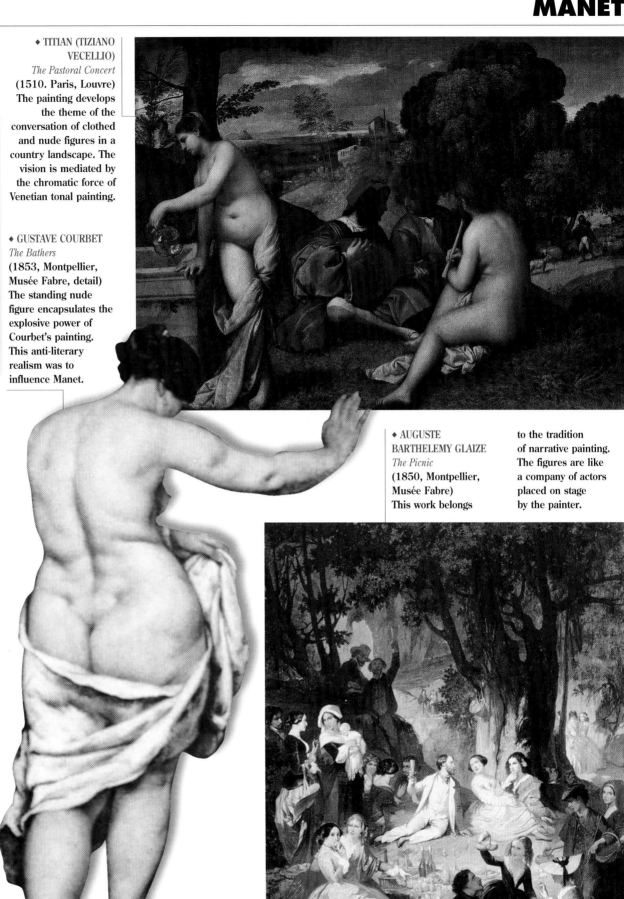

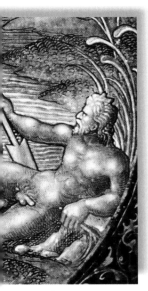

◆ TITIAN (TIZIANO VECELLIO)
*The Pastoral Concert*
(1510. Paris, Louvre)
The painting develops the theme of the conversation of clothed and nude figures in a country landscape. The vision is mediated by the chromatic force of Venetian tonal painting.

◆ GUSTAVE COURBET
*The Bathers*
(1853, Montpellier, Musée Fabre, detail)
The standing nude figure encapsulates the explosive power of Courbet's painting. This anti-literary realism was to influence Manet.

◆ LE DÉJEUNER SUR L'HERBE
(c. 1863-67, London, the Courtauld Institute Galleries)
This preparatory sketch for the painting of the same name is reminiscent in its rapid, vibrant execution of the earlier work *Concert in the Tuileries Gardens*.

◆ AUGUSTE BARTHELEMY GLAIZE
*The Picnic*
(1850, Montpellier, Musée Fabre)
This work belongs to the tradition of narrative painting. The figures are like a company of actors placed on stage by the painter.

13

# PAINTING AND PHOTOGRAPHY

Manet's critical attitude towards the conventions of contemporary society manifests itself primarily in his adoption of a daring and deeply innovative style. On the threshold of a new aesthetic vision, of an art free from anecdote and all narrative superstructure, the subject is subordinated to skill in pictorial execution. Unlike most of his contemporaries, Manet appreciated and applied the results of photography openly and with no prejudice in an intelligent endeavor to create interaction between the two semiotic systems. The setting of *Le Déjeuner sur l'herbe* appears in fact to have been inspired by a corner of the island of Saint-Ouen.

● The painting is built up on strong contracts of light and shadow with no chiaroscuro modulation. The light is not a beam but a quality of the color, as is the shadow, which divides the canvas into large flat patches. Manet is a sophisticated and elegant painter of surfaces. Radiant and cursorily modeled with no half tones, Victorine's body is thus volume in itself, the orphan of a linear constructional design. Remembering the great seventeenth-century Flemish tradition, the velvet blacks of Frans Hals, and the broad brushstrokes and transparent glazing of Spanish painting from Velázquez and Murillo up to Goya, Manet organizes his own canvas in terms of vigorous, determined brushstrokes.

● The browns, whites and luminous blacks triumph superbly on a screen of refractive light in structural syntheses of great modernity. No use is made of the Impressionists' *plein air* technique, the artist is still working in the studio, but we already sense the freshness in the air. The subject already appears to have been painted from life.

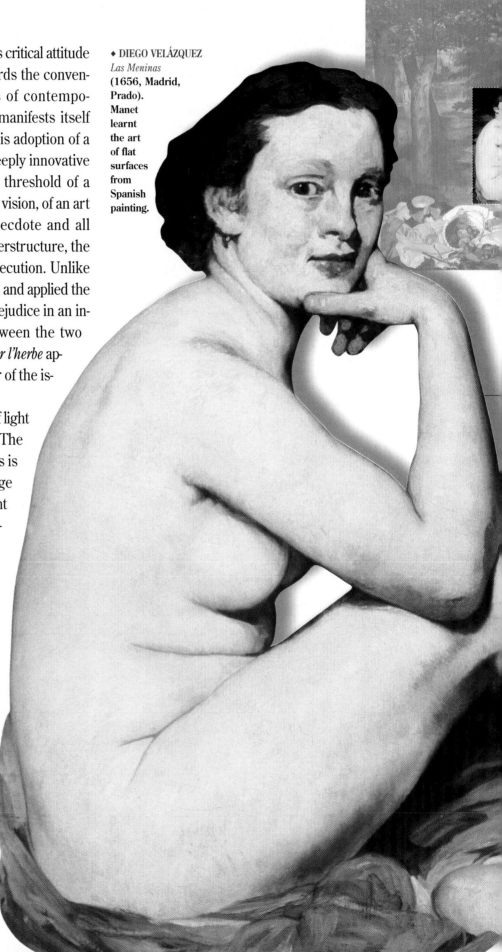

◆ DIEGO VELÁZQUEZ
*Las Meninas*
(1656, Madrid, Prado). Manet learnt the art of flat surfaces from Spanish painting.

◆ VICTORINE MEURENT
Portrayed in the
detail shown
alongside,
the model Victorine
Meurent was
to accompany
Manet throughout
his artistic career.
In depicting
the forms of her body,
the master tends
to emphasize the
strictly carnal aspect
of the nude, plunging
it into a dimension
of sophisticated
sensuality.

◆ IN THE SHADE
OF THE CLEARING
Manet is known
to have used
photography
to depict the
landscape in
*Le Déjeuner sur l'herbe*.
With profoundly
modern intuition,
he understood that
the revolution brought
about by the new
technique of
representation could
be harnessed
in painting.
He thus exploited
the speed and
precision of the
camera, the only device
capable of capturing
the aspects of reality
that escaped his eye.

◆ FRANS HALS
*Banquet of Officers*
*of the Civic Militia*
*of St George in Haarlem*
(1616, Haarlem,
Frans Halsmuseum)
During his journey
in Holland in 1856,
Manet was entranced
by the work
of Frans Hals.
In this painting,
Hals presents
a cross-section
of the military
order to which
he belonged.
Seventeenth-century
Dutch portraits
were to be a great
source of inspiration
to Manet. Like Hals,
Manet used
black as pure color.

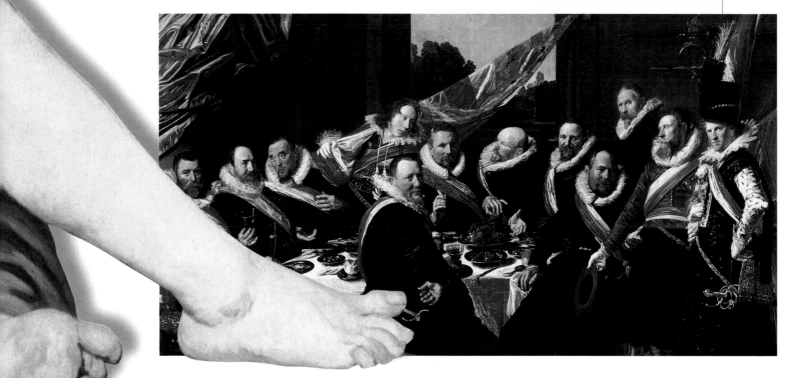

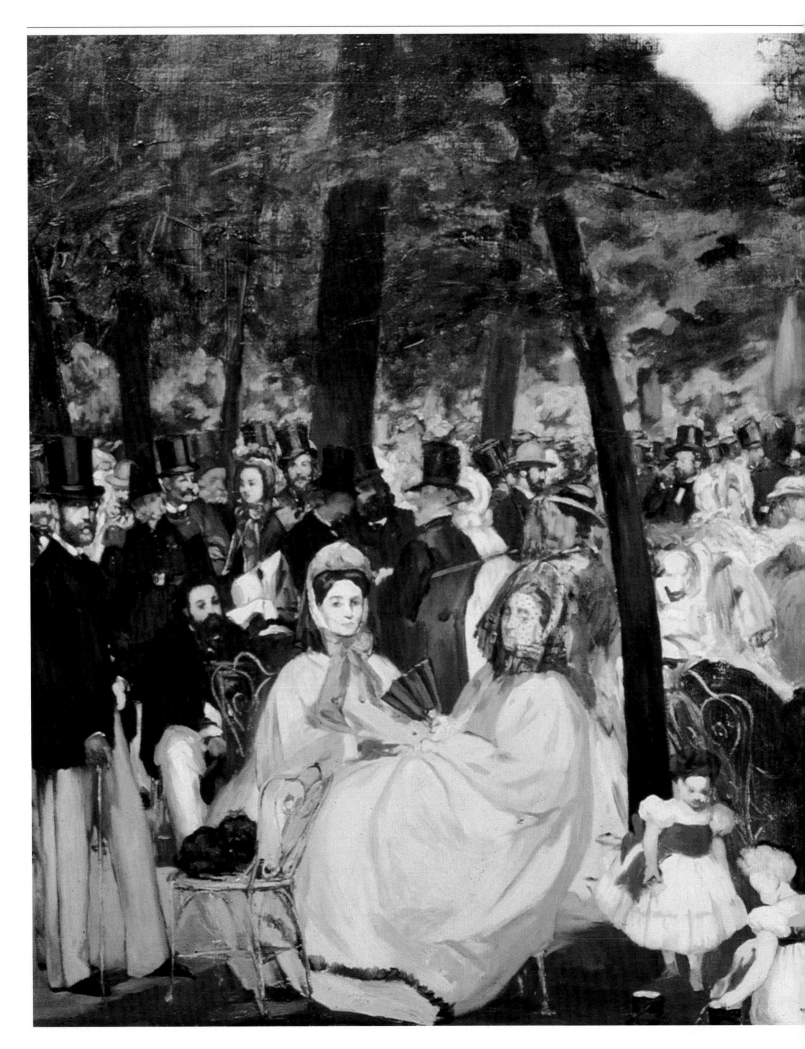

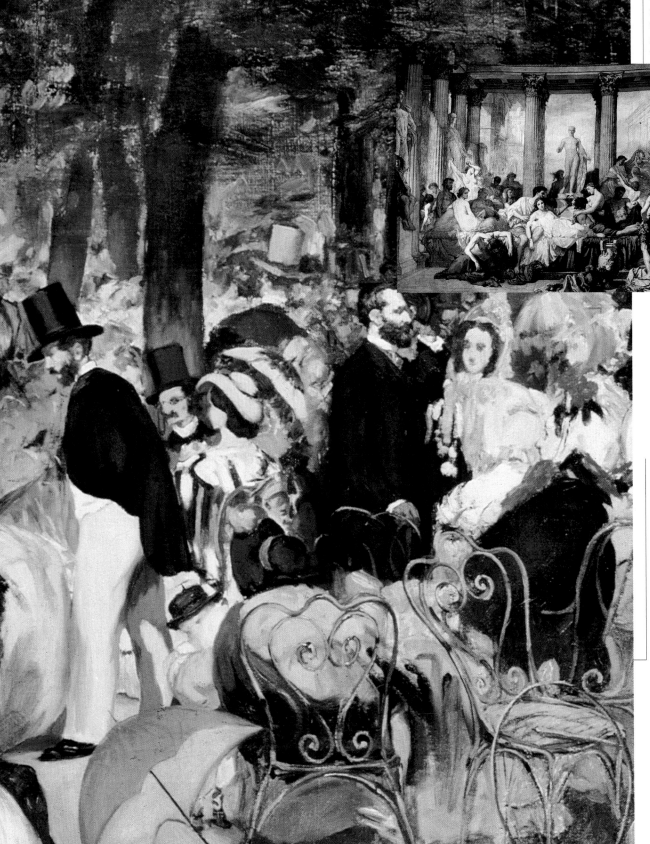

♦ THOMAS COUTURE
*The Romans of the
Decadence*
(1847, Paris,
Musée d'Orsay)
Couture, Manet's first
teacher, constitutes
the prototype of the
academic painters in
vogue at the Salon.

♦ CONCERT IN THE
TUILERIES GARDENS
(1862, London,
National Gallery)
Held up in comparison
with works by his own
teacher, this painting
did a fair amount of
harm to Manet's
reputation. The critics
reacted indignantly to
this crowded, bustling
canvas. The poet
Charles Baudelaire was
the only one to praise
Manet's painting,
pointing out its
aesthetic modernity.
Among the many
figures it is possible to
recognize the painter
himself, his brother
Eugène, and many of
his friends including
Baudelaire, Astruc and
Gautier. The work
offers a view of the
elegant, fashionable
society to which Manet
belonged.

# THE PAINTER OF MODERN LIFE

"We must be of our own time and paint what we see," proclaimed Edouard Manet. His artistic career ran parallel to the intricate development of this assertion. After initial difficulties – his father wanted him to take up law – and naval experience on a transport vessel bound for Rio de Janeiro, Manet's sincere passion and vocation for painting found an outlet only in 1850, when he overcame his father's objections and went to study with Thomas Couture.

● Middle-class by birth, elegant and sophisticated, this perfect man of the world made his entrance into the Olympus of art, the circles of the Salon, through the front door. Couture based his teaching of the craft on the use of models in the studio, following the academic tradition, but Manet was immediately impatient and intolerant of such rigid and exaggerated poses. He began to ignore the rules of the Salon painters and went in search, as Antonin Proust recalls, of "living things to paint outside". He rebelled. In the Louvre he copied Velázquez, Murillo and Rembrandt. He took an interest in Delacroix against Couture's wishes, and his painting of *The Absinthe Drinker* marked the end of their relationship. Manet developed his art through journeys in Holland, Germany, Austria, Prague and Italy, where he copied the great

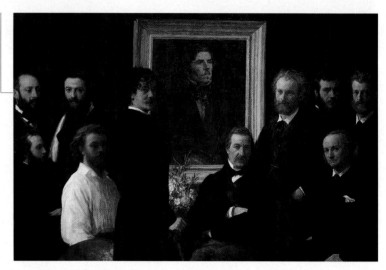

◆ HENRI FANTIN-LATOUR
*Homage to Delacroix*
(1864, Paris, Louvre). Manet is represented here among other artists and intellectuals.

masters of the Renaissance, and commenced his career in the contemporary art world in isolation.

● A lover of music, the friend of Baudelaire and subsequently of Zola and Mallarmé, he animated the evenings at the Café Guerbois, where the bohemian set of the period met. His *Concert in the Tuileries Gardens* portrays a cross-section of the upper middle-class society into which he was born and conjures up the bustle of fashionable Parisian life. The novelty of the painting aroused controversy, as did the later works *Le Déjeuner sur l'herbe* and *Olympia*. The target of violent attacks for his free style of painting outside the official canons, the painter, who sole aspiration was the consecration of his own Paris, remained artistically isolated throughout his life.

● Rightly considered one of the fathers of Impressionism, Manet never exhibited his work with the group, though following their development with interest and appreciation, and began to experiment with painting *en plein air* only in his last years. Involved in a renewal of art that takes tradition as its starting point only to debunk and undermine it, praiseworthy for disrupting the rigid hierarchy of genres and annihilating any distinction between the representation of everyday objects and the traditionally paramount subject of the human figure, this "painter of modern life", this intellectual artist, sought only to narrate the epic aspect of everyday life in the "definitive silence of painting" (Bataille). As Edgar Degas rightly observed at his grave, "He was greater than we thought."

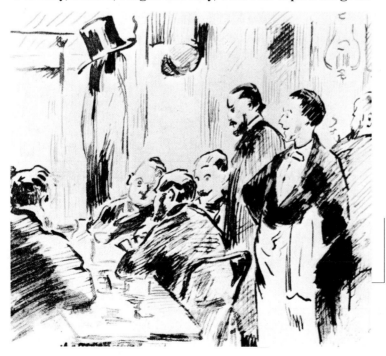

◆ THE CAFÉ
(1869, Cambridge, Mass., Fogg Art Museum, Harvard University)
This sketch in pen and Indian ink portrays an evening at the Café Guerbois.

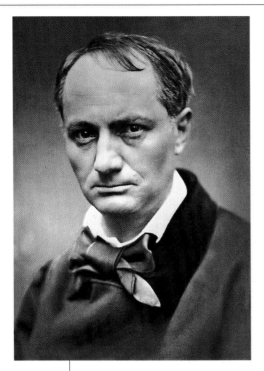

◆ ETIENNE CARIAT
*Portrait of Baudelaire*
Photograph
of the poet,
a great friend and
admirer of Manet.

◆ HENRI FANTIN-LATOUR
*Portrait of Manet*
(1867, Chicago
Art Institute).
Fantin-Latour celebrates
the painter of modern
life in an intense portrait
of photographic
realism.

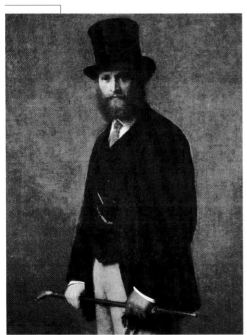

◆ THE ABSINTHE
DRINKER
(1858-59, Copenhagen,
Ny Carlsberg Glyptotek)
This painting marked
the end of Manet's
relationship with his
teacher Couture.
Rejected by the Salon
jury of 1859, the
portrait of the alcoholic
Collardet illustrates the
artist's radical
conversion to the
portrayal of an anti-
heroic world close to
the dissolute universe
of his friend Baudelaire.

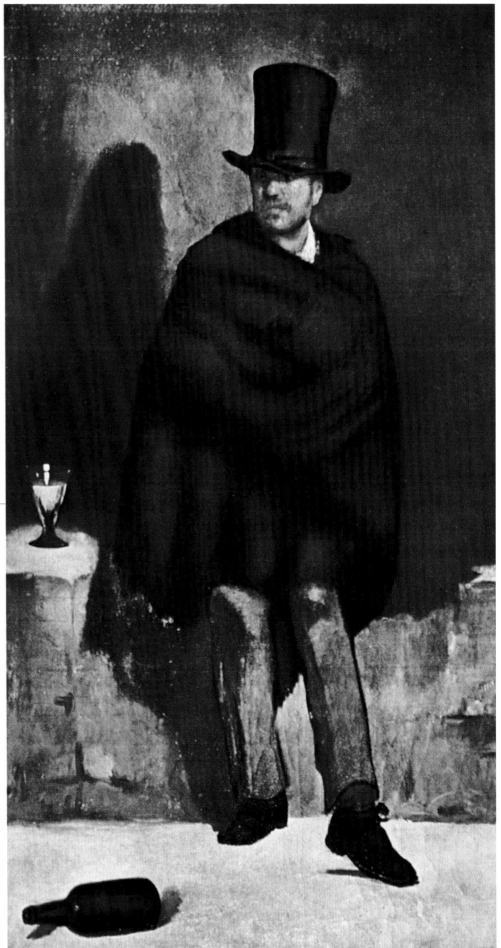

# THE PAINTER OF FIGURES

Manet is not a landscape painter. A central theme in his poetic universe is the portrayal of the human figure, often in an interior. Naturalistic elements are usually just sketched to form the background of a composition where figures predominate.

● During the 1860s Manet tackled the subject of the female nude, which constituted one of the pillars of the Salon culture from the seductive canvases of Cabanel to Courbet's crude and uninhibited works. Manet's attachment to tradition led him to produce a sort of trilogy: *The Startled Nymph*, *Le Déjeuner sur l'herbe* and *Olympia*. Reworking mythological themes drawn from Rubens or Boucher's sophisticated eroticism, Manet developed from the *Nymph* of 1861 to the unadorned sensuality of *Olympia*, where he continued the experimentation of the *Déjeuner* to refine the relationship between light and color.

● Figure analysis has its own specific sphere of application in the portrait. Initially modeled on the Spanish court paintings of Velázquez and Goya and the bourgeois iconography of Frans Hals, then on the rapid, vibrant brushstrokes of the Impressionists, Manet's portraits never overstep the mark. Fascinated by the construction of space in Oriental art, Manet adopted the perspective approach of the Japanese prints circulating in Paris – and dear to both Degas and Monet – to make his compositions more dynamic. He was not interested in psychological introspection but sought rather to characterize his figure

◆ THE STARTLED NYMPH (1861, Buenos Aires, Museo Nacional de Bellas Artes). This is one of Manet's very few paintings on mythological subjects. Forming part of a sort of trilogy with the Victorine of the *Déjeuner* and *Olympia*, the nymph stems directly from Rubens' *Susanna and the Elders*. The bashful pose of the female figure was later to give way to the unabashed nude of the *Déjeuner*.

through the everyday items portrayed in the painting. The empty, isolated, absent gaze of the figures attests to the painter's detachment from Romantic pathos and the sphere of sentimental expression. From *Mademoiselle Victorine in "Espada" Costume* and *The Fifer* to the portrayal of Théodore Duret and the portraits of his friends, including Zola, Zacharie Astruc, Berthe Morisot and Mallarmé, Manet's apparently superficial genius triumphed in its sincere adherence to reality.

● In his scenes of contemporary life, on the other hand, Manet anticipated the subjects tackled by the Impressionists, specifically Toulouse-Lautrec, Degas and Renoir. In the *Concert in the Tuileries Gardens* of 1862, despite the scarce dynamism of the figures, which are crowded together and appear to flatten out on the canvas, Manet already revealed his passion for the urban universe. Over the years he was to concentrate increasingly on portraying his intellectual friends and common folk set in the urban environment of the *café-concerts*, bistros, racetracks and whirling fancy-dress balls. In order to render the vibrancy of the contemporary atmosphere in formal terms, Manet's pictorial touch was to become lighter, his handling of light was to become flaky, and his canvases were to show concrete signs of experimentation with painting *en plein air*. He was thus to paint horse-racing scenes like Degas, and from 1871 on often went to Argenteuil with Monet to paint the same subjects. But his brushstroke was always to remain clean, never thickly laden with paint, and deliberately compositional.

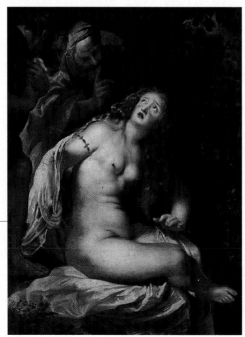

◆ PETER PAUL RUBENS *Susanna and the Elders* (1607, Rome, Galleria Borghese) A subject painted by many artists in the Renaissance and the seventeenth century, Rubens' Susanna is characterized by the thick, vibrant brushstrokes of the composition. The rich painting lends drama to the scene.

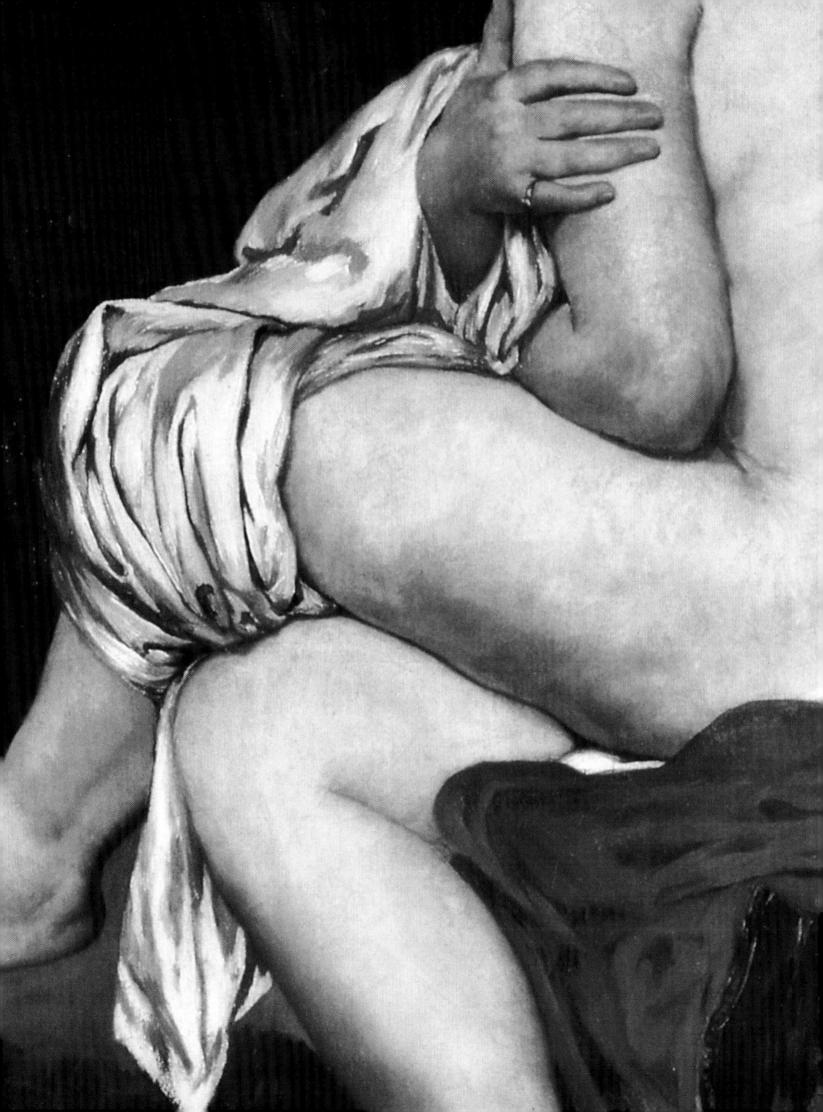

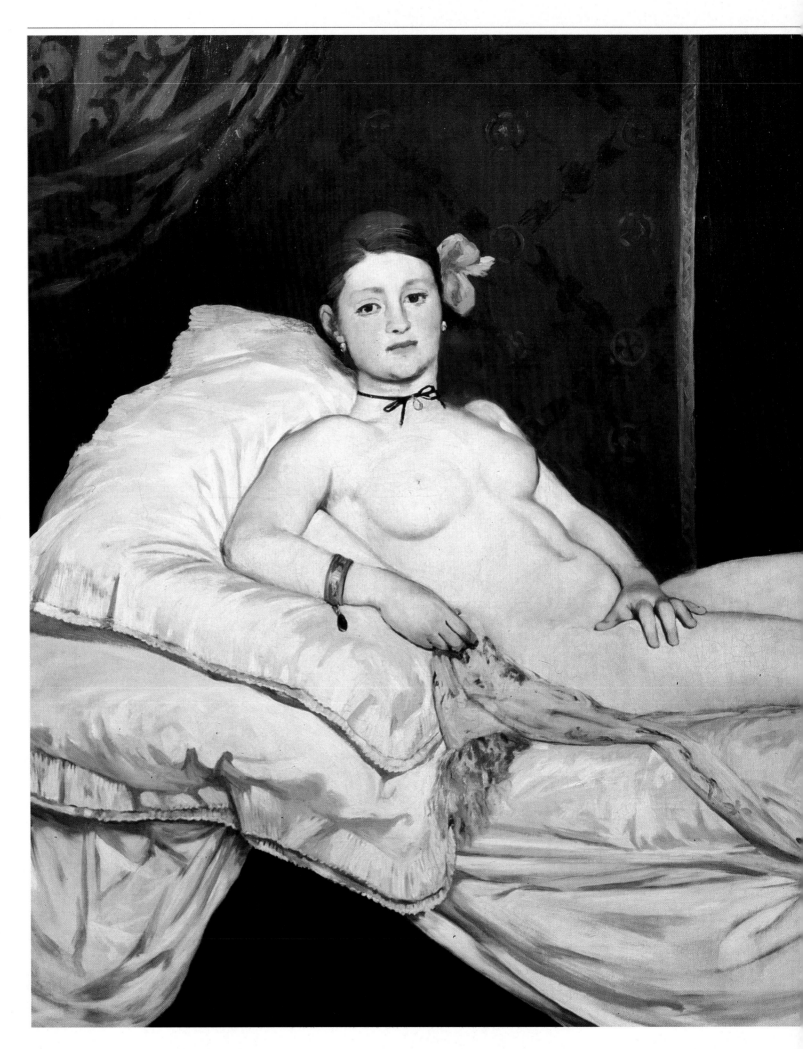

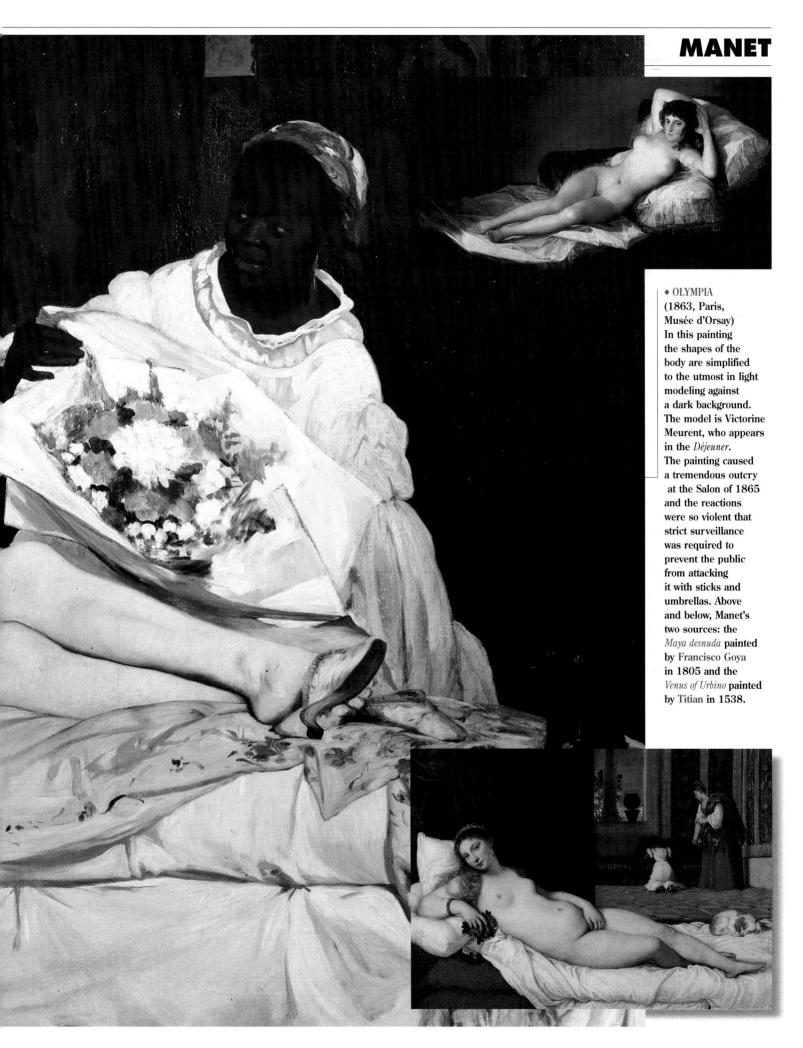

♦ OLYMPIA
(1863, Paris,
Musée d'Orsay)
In this painting
the shapes of the
body are simplified
to the utmost in light
modeling against
a dark background.
The model is Victorine
Meurent, who appears
in the *Déjeuner*.
The painting caused
a tremendous outcry
 at the Salon of 1865
and the reactions
were so violent that
strict surveillance
was required to
prevent the public
from attacking
it with sticks and
umbrellas. Above
and below, Manet's
two sources: the
*Maya desnuda* painted
by Francisco Goya
in 1805 and the
*Venus of Urbino* painted
by Titian in 1538.

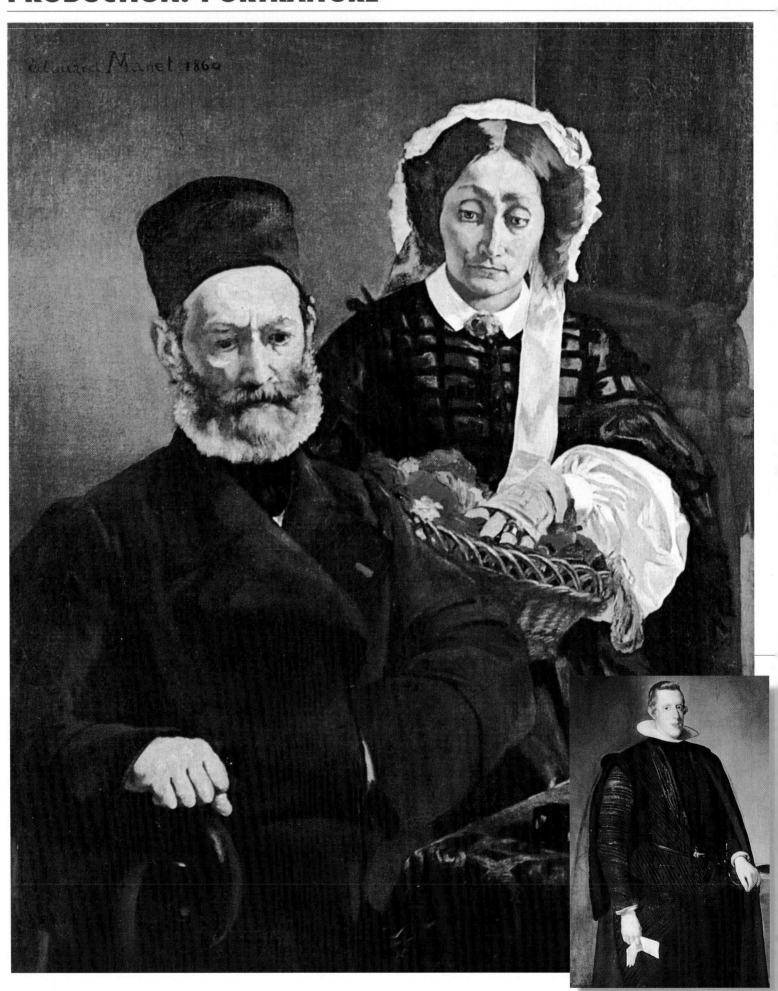

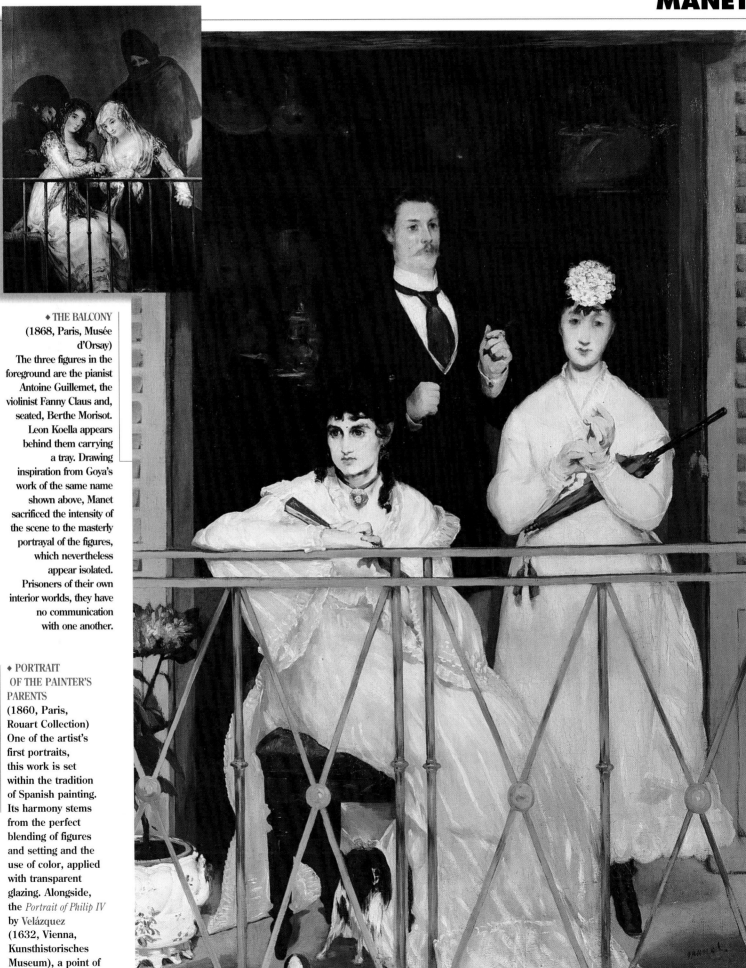

◆ THE BALCONY
(1868, Paris, Musée
d'Orsay)
The three figures in the
foreground are the pianist
Antoine Guillemet, the
violinist Fanny Claus and,
seated, Berthe Morisot.
Leon Koella appears
behind them carrying
a tray. Drawing
inspiration from Goya's
work of the same name
shown above, Manet
sacrificed the intensity of
the scene to the masterly
portrayal of the figures,
which nevertheless
appear isolated.
Prisoners of their own
interior worlds, they have
no communication
with one another.

◆ PORTRAIT
OF THE PAINTER'S
PARENTS
(1860, Paris,
Rouart Collection)
One of the artist's
first portraits,
this work is set
within the tradition
of Spanish painting.
Its harmony stems
from the perfect
blending of figures
and setting and the
use of color, applied
with transparent
glazing. Alongside,
the *Portrait of Philip IV*
by Velázquez
(1632, Vienna,
Kunsthistorisches
Museum), a point of
reference for Manet.

# PRODUCTION: PORTRAITURE

◆ PORTRAIT OF STÉPHANE MALLARMÉ (1873, New York, Museum of Modern Art) This painting stems from the close friendship between the two artists. The use of quick, vibrant brushstrokes bears witness to the painter's interest in the Impressionist technique. Manet presents the poet reclining in an armchair with an absorbed expression wrapped up in intimate existential reflection.

◆ THE READING (1868, Paris, Musée d'Orsay) The two figures are Manet's wife, Suzanne Leenhoff, and Leon Koella, reading to her from a book.

While the female figure is enthroned on the sofa, only Koella's face and arms are visible. Here Manet adopts the singular style of the Japanese prints he so admired and purchased in Paris. The use of white, which radiates light over the canvas like a refractive screen, derives instead directly from the work of the American painter James Whistler, a great friend of Manet's. In *Symphony in White n. 2: the Girl in White* of 1864 (left), Whistler reveals his own love of Japanese art, underscored by the porcelain vase and fan with cherry blossoms. Both artists express a sophisticated, aesthetic view of art.

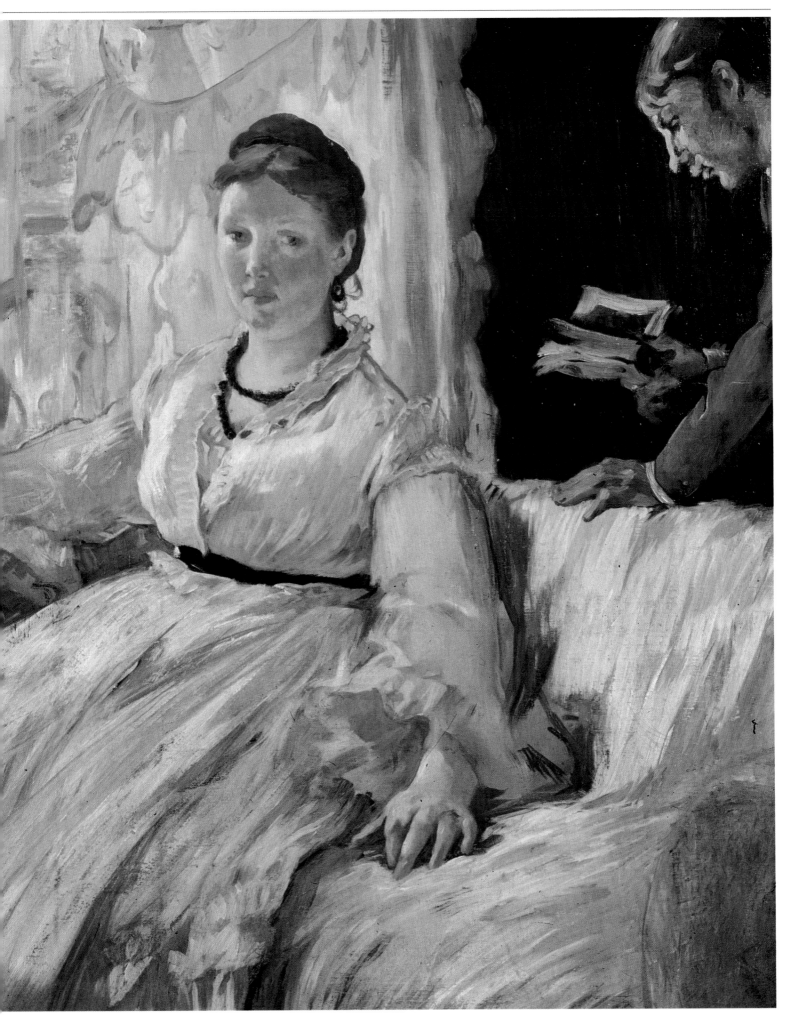

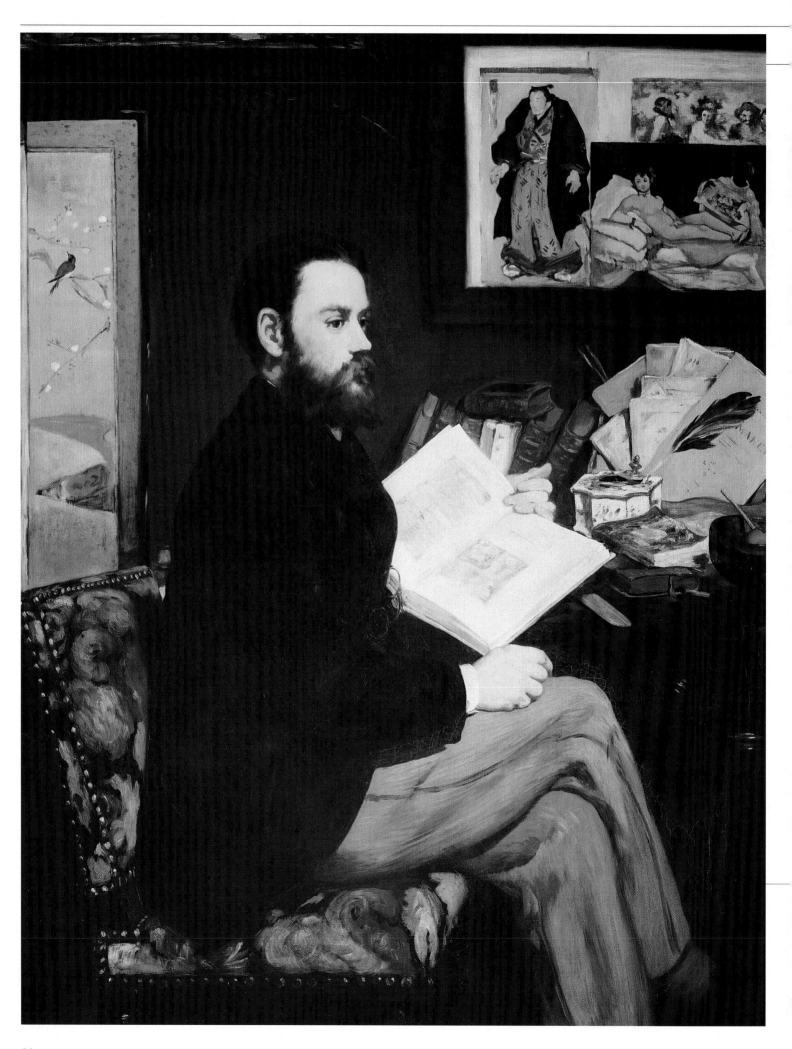

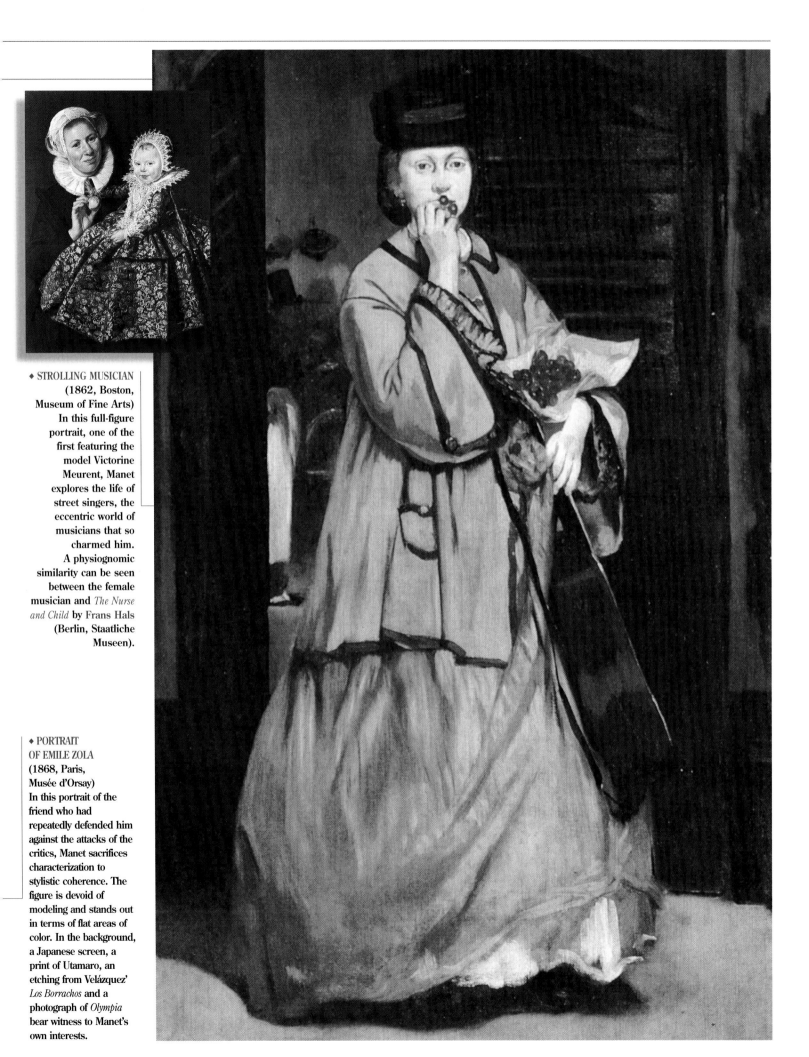

◆ STROLLING MUSICIAN
(1862, Boston,
Museum of Fine Arts)
In this full-figure
portrait, one of the
first featuring the
model Victorine
Meurent, Manet
explores the life of
street singers, the
eccentric world of
musicians that so
charmed him.
A physiognomic
similarity can be seen
between the female
musician and *The Nurse
and Child* by Frans Hals
(Berlin, Staatliche
Museen).

◆ PORTRAIT
OF EMILE ZOLA
(1868, Paris,
Musée d'Orsay)
In this portrait of the
friend who had
repeatedly defended him
against the attacks of the
critics, Manet sacrifices
characterization to
stylistic coherence. The
figure is devoid of
modeling and stands out
in terms of flat areas of
color. In the background,
a Japanese screen, a
print of Utamaro, an
etching from Velázquez'
*Los Borrachos* and a
photograph of *Olympia*
bear witness to Manet's
own interests.

# PRODUCTION: SCENES OF FASHIONABLE LIFE

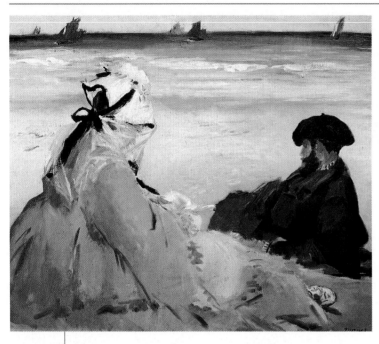

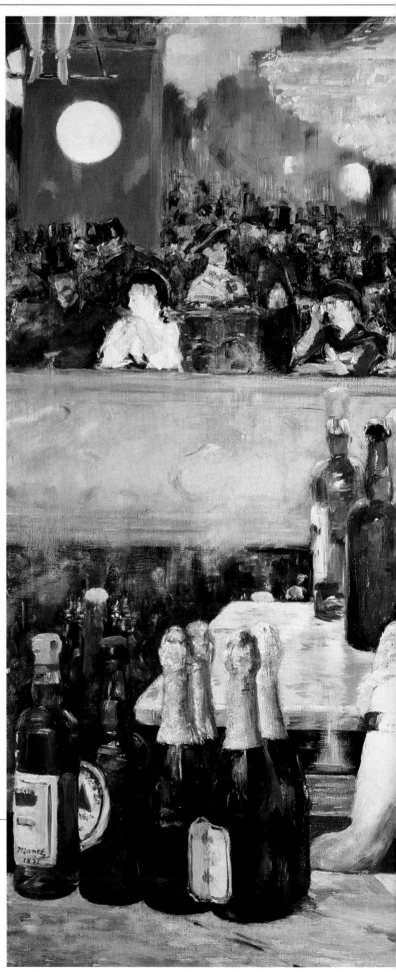

♦ ON THE BEACH
(1873, Paris, Musée d'Orsay)
The work shows the painter's wife and brother at Beck-sur-mer in the summer of 1873. The summarily delineated figures are endowed with volume by their tonal relationship. The light is still a quality of the color and permits the simplification and precision of the image as a whole.

♦ THE RACES AT LONGCHAMPS, PARIS
(1864, Chicago, Art Institute)
For a short period of 1864 Manet frequented the racetracks. This choice of subject seems to link him to the studies of horses executed by Degas, who indeed accused him of plagiarism. The skill with which the painter succeeds in conjuring up the race, capturing forever the instant in which the horses and jockeys flash by, is truly amazing given his lack of interest in the expression of dynamic action and preference for static, measured poses. Here instead the central group of horses seems about to burst out of the space of the canvas and trample the viewer.

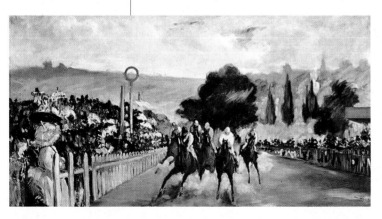

♦ BAR AT THE FOLIES-BERGÈRE
(1881-82, London, Courtauld Institute)
This is the last great work devoted to contemporary life by the painter, already weakened by illness. The glow of the colors and the gaslights is reflected in the mirror, the glassware and the bottles to create an almost unreal atmosphere. Manet captures the ephemeral existence of the world of nocturnal pleasures. The reflection in the mirror helps to surprise the forms in their lively mobility. The pink-complexioned figure in the foreground is enchanting. Behind her we can almost hear the hum of voices and the tinkling of glasses.

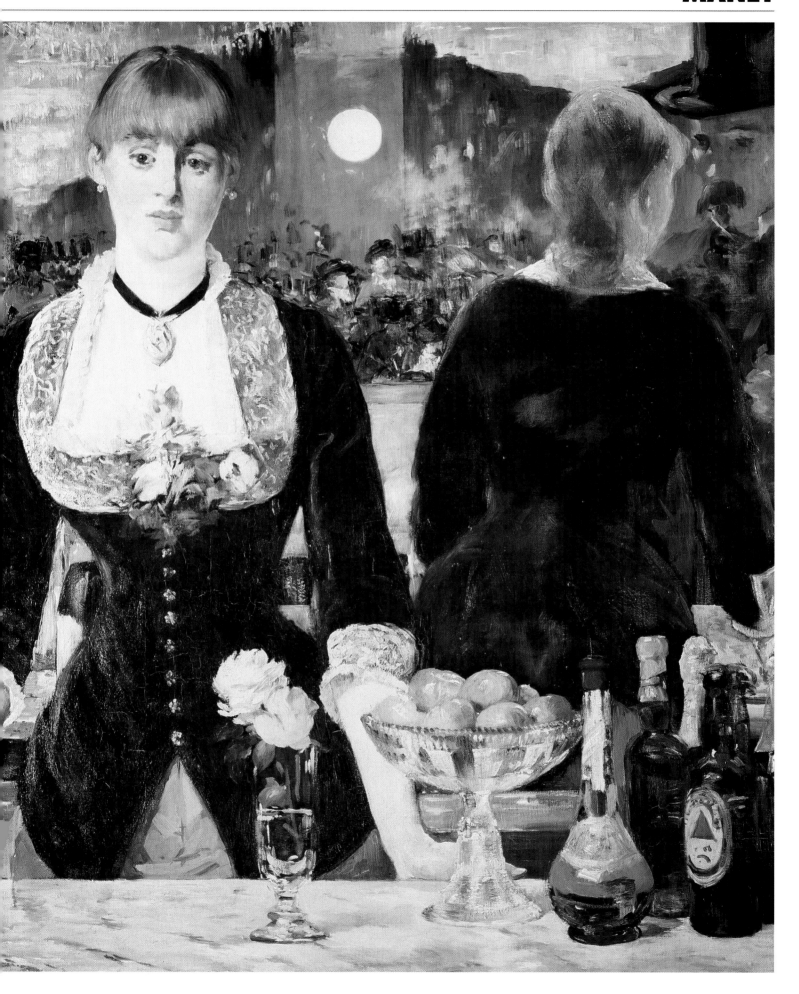

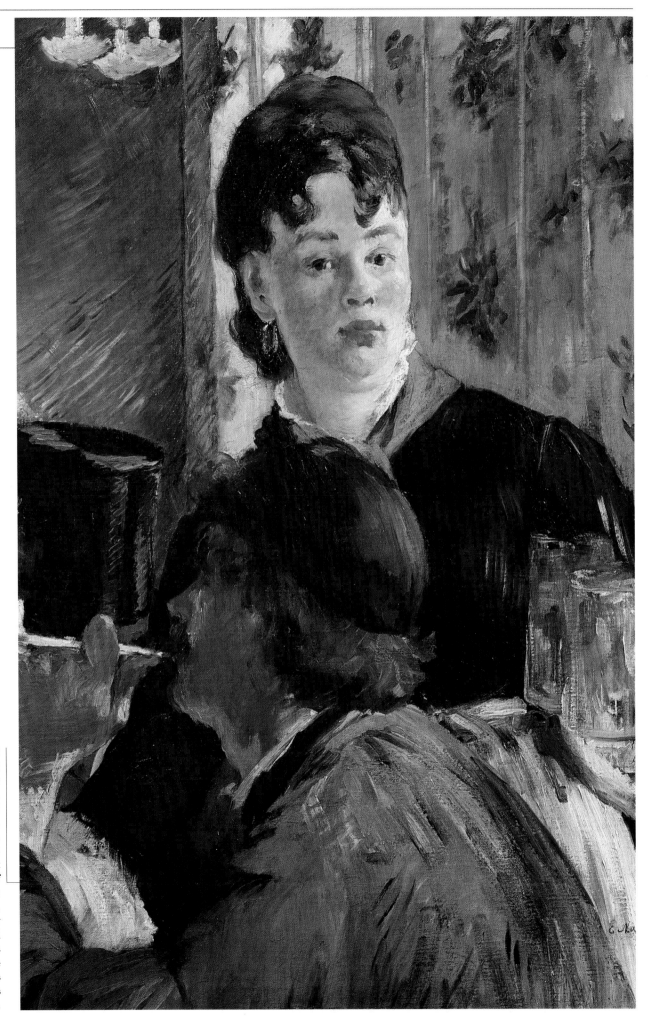

◆ AT THE
CAFÉ-CONCERT
(1878, Baltimore,
Walters Art Gallery)
Manet, the painter
of fashionable
life, was a keen
habitué of cafés,
where music
was normally
performed.
A banal scene
provides the
painter with
the opportunity
to capture
a fragment of life.
His aim is in fact
to celebrate
the events animating
the fashionable
Paris of his day.

◆ LA SERVEUSE
DE BOCKS
(THE WAITRESS)
(1879, Paris,
Musée d'Orsay)
The cabarets,
their customers,
waiters and waitresses
inspired Manet to paint
a whole series of
canvases. This is the
Brasserie Reichsofen,
frequented by
musicians, actors and
artists. The painter's
eye anticipates the
photographic zoom lens
as it focuses on scenes
of contemporary life.

# STYLISTIC EXERCISES IN AN INTERIOR

From the very outset, Manet made space for the composition of still lifes, painting flowers, fruit and everyday objects, and exercising his worldly genius on a vast range of gastronomic delicacies. From the 1860s to the painter's death, the still life came to acquire the same importance in his universe as is attributed to his figure paintings. Like François Bonvin (1817-1887), the author of impressive still lifes who showed him the way, Manet exploited the strong contrast between black and white, juxtaposing the dark wood of the table to the luminous tablecloths and serviettes, where he played with a vast array of variations in color.

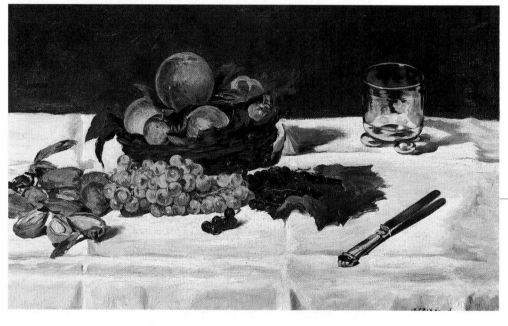

● These compositions served as a workshop of chromatic studies where Manet developed his virtuoso painting technique in trying out devices for more complex works. In *Luncheon in the Studio*, for example, the figure in the foreground is not the central nucleus of the painting but simply an artifice, an enchanting and original pictorial device that allows the gaze to probe further, exploring the richness of the still life in all its minute detail. It is in this painting that the master's free and highly innovative vision of painting fully manifests itself. The juxtaposition of the human figure with an oyster or a lemon leads to the total dissolution of any hierarchy in the organization of the pictorial space. The artist's only concern is to do justice to the nobility of the art simply by painting well. The application of color, the blending of light hues, and the ability to endow the simplest and most anonymous subject with poetry raise Manet to the peak of artistic expression.

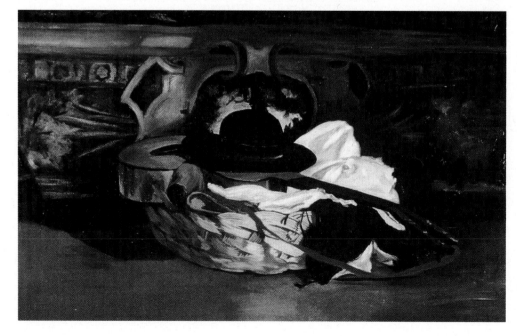

● His manner, the elegance and sobriety with which he uses color, the delight in painting and his natural detachment from any narrative intent are the characteristic features of a profoundly modern approach to painting. Manet imposes silence upon the viewer, inducing an admiration where no judgement is admitted. This aesthetic approach was to spread to the Impressionists themselves and all subsequent painting.

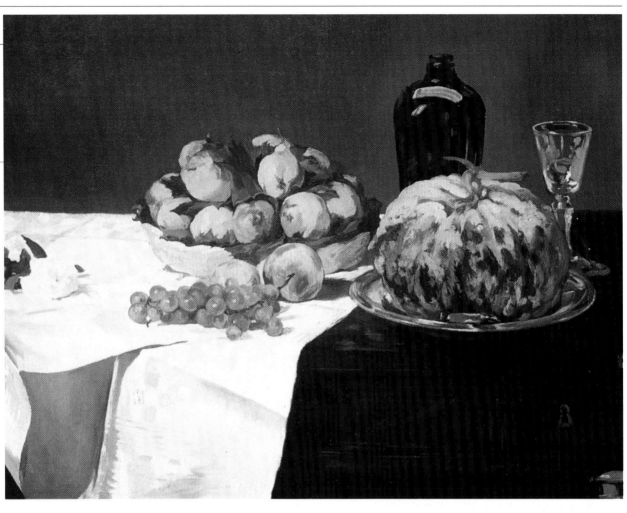

◆ STILL LIFE
WITH MELON
AND PEACHES
(1866, Washington,
National
Gallery of Art)
An example of Manet's
skill in juxtaposing
colors. The limpidity
and volume
of the objects
is enhanced
by the dazzling white
of the tablecloth.

◆ FRUIT ON A TABLE
(1864, Paris,
Musée d'Orsay)
The reasons
inducing Manet
to paint still
lifes include
the immediate
availability
of models and
the ease with which
such works could
be sold.
These subjects also
offer an excellent basis
for formal exercises.

◆ STILL LIFE
WITH FISH
AND OYSTERS
(1864, Chicago,
Art Institute)
This work was
to have been
exhibited in 1865
by the critic Martinet.
According to
Emile Zola, still lifes
were the works
by Manet most
appreciated
by contemporaries.

◆ STILL LIFE
WITH SOMBERO
AND GUITAR
(1862, Avignon,
Musée Calvet)
The painting, shown
at the bottom
of the opposite page,
testifies to Manet's
interest in Spanish
culture. The same
themes reappear in
the portrait of
*Victorine Meurent in
"Espada" Costume*
and the numerous
bullfighting scenes.

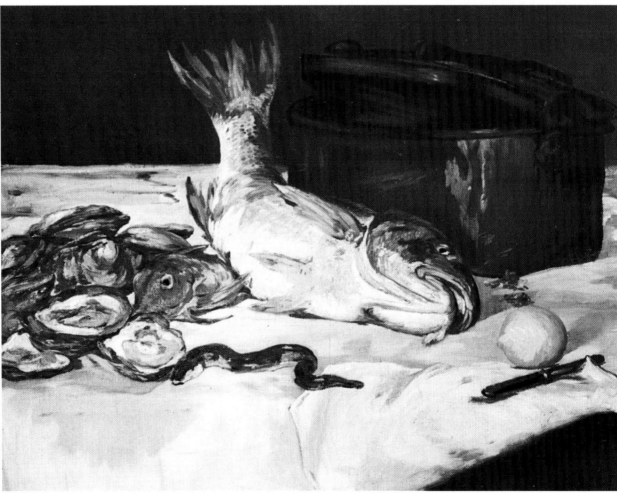

◆ THE ASPARAGUS
(1880, New York,
Sam Salz Collection)
Painted at the end
of Manet's career,
this canvas fully
demonstrates
the master's skill.
It is not only
a still life.
The asparagus
in the foreground
seems to take
on an absolute
value. Its presence
signifies the absence
of any centrality
for the human being.
The painting is an act
of faith in painting, a
challenge to the
academic world.
From the technical
viewpoint, it can
be regarded as one
of the highest
quality paintings
in this genre ever
produced by Manet.
Applying the
Impressionists'
discoveries in
original fashion,
Manet dissolves the
object into the fluid
substance of color.

# AESTHETIC COHERENCE

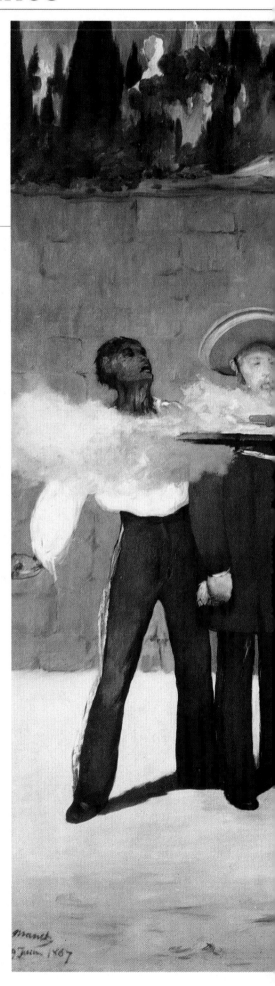

I f we take the still life as our starting point, it is easy to understand the importance attributed by Manet to the production of three works that critics find it hard to place: *Christ with Angels*, *Naval Battle between the Kearsage and the Alabama* and *The Execution of the Emperor Maximilian of Mexico*. These three paintings portray historical or religious events but empty them of any heroic or transcendental character to focus on the plastic-pictorial value of the scene. The *Christ with Angels* of 1864 presents itself as a declared tribute to seventeenth-century painting, to Caravaggio's masterly realism and the limpid, transparent tonalities of Spanish art. In the *Naval Battle* and the *Execution*, Manet instead draws inspiration respectively from an episode in the American Civil War and the execution of

◆ THE EXECUTION OF EMPEROR MAXIMILIAN OF MEXICO (1867, Mannheim, Kunsthalle) Inspired from Goya's *The 3rd of May 1808: the Execution of the Defenders of Madrid*, the work of Manet is totally free of rhetoric (and denies the tragic nature of the event).

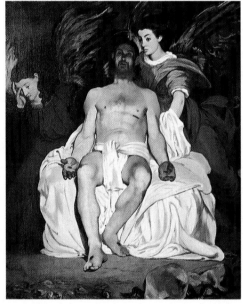

Maximilian of Austria, recently proclaimed emperor of Mexico. As in his reworking of the classical mythological subjects of Renaissance painting, Manet attenuates the drama of the scene, interpreting it in terms of his own pictorial sensibility and eliminating any narrative aspect or emotive projection through detached, objective execution. Everything else is cancelled out in the expression of the strictly formal value of the work of art. These works were aimed at the Salon culture, created in a sincere attempt to adapt to the taste of the critics and artists of the academic circles and somehow receive from them the recognition so long desired. Unfortunately, the three works came under violent attack and aroused general indignation. Only Baudelaire sided with Manet and defended his aesthetic coherence.

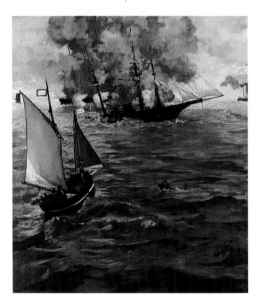

◆ NAVAL BATTLE BETWEEN THE KEARSAGE AND THE ALABAMA (1864, Philadelphia, John G. Johnson Collection) Together with the *Christ with Angels* (1864, New York, Metropolitan Museum) above, this painting demonstrates Manet's interest in a transparent and luminous style of painting despite the use of black.

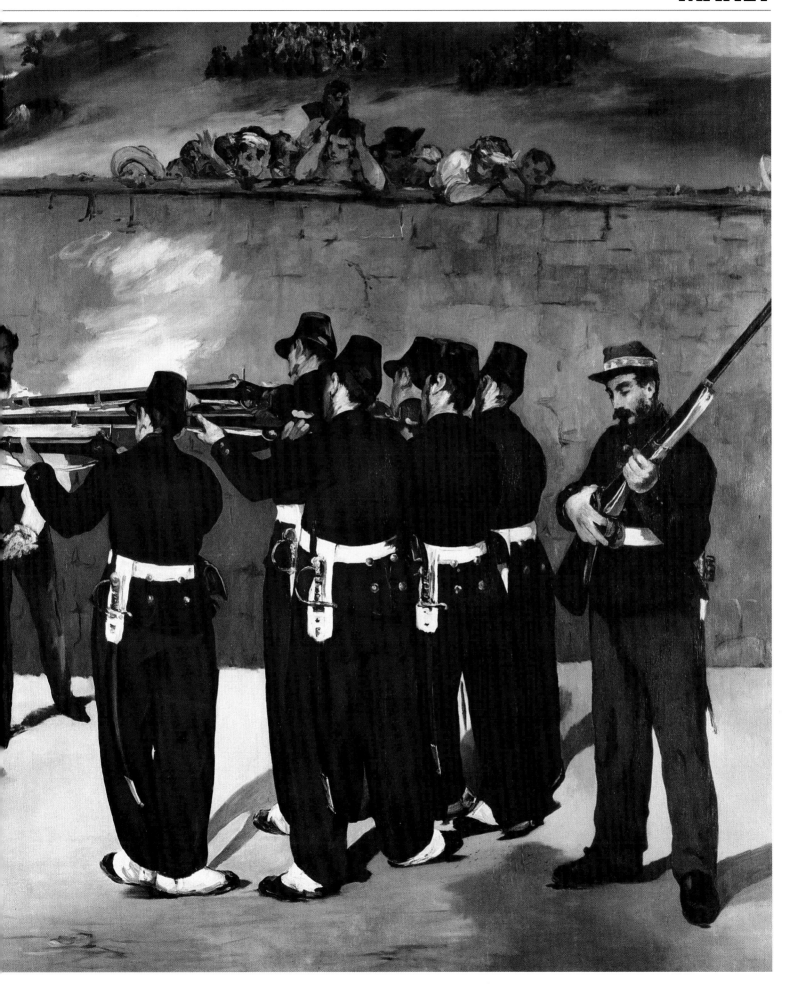

# THE PROTAGONISTS OF AN ERA

M anet was born in a period of great structural innovations that led to decisive changes also in the spiritual sphere. The industrial revolution, the growth of the proletariat and the triumph of the bourgeoisie led to the development of the great urban centers. At the Salon of 1846, Baudelaire, a friend of Manet's and a critical interpreter of the *new*, celebrated the "heroism of modern life".

● Karl Marx's *Manifesto of the Communist Party* was published in 1848 and Europe was rocked by revolution. While the architectonic and sociological universe of the new continental metropolises began to penetrate the consciousness of poets and writers, Manet embarked as an apprentice pilot on a transport vessel bound for the South Seas.

● On his return home and during his apprenticeship with Thomas Couture, the political situation underwent a radical change. On 2 December 1852, Napoleon III proclaimed himself emperor. Paris became the *ville des lumières*. The prefect Haussmann gutted the medieval fabric of the city to create the great boulevards.

● In 1857 Flaubert published *Madame Bovary* and Courbet painted the *Young Women on the Banks of the Seine*. In the same period, Baudelaire published *Les Fleurs du Mal*. Deeply influenced by this atmosphere, Manet painted *The Absinthe Drinker* in 1858, drawing inspiration from Baudelaire's *Les Paradis Artificiels*. Realism triumphed in painting with Courbet and Manet, in literature with Maupassant and Zola.

Painters and writers were united in protest against the inane sentimentalism and empty idealism of their Romantic predecessors. Realism was above all the demand for freedom, the denial of the ideal, the rejection of the academic and conventional style.

● In Paris Manet frequented Baudelaire and Zola, the critics Champfleury, Duret and Duranty, and the painter Fantin-Latour at the Café Guerbois. The 1860s were crucial in forming the painter's intellectual and artistic orientation. He met Degas, the model Victorine Meurent, Monet, Nadar and Bazille. After the scandals of the *Déjeuner* and *Olympia*, Manet was violently attacked by the official critics but defended by Baudelaire and Zola. In 1869 Monet, Sisley and Cézanne were also rejected at the Salon.

● In 1870 the Franco-Prussian War broke out and Manet enlisted in the National Guard. On 18 January 1871 the German Empire was proclaimed at Versailles. The revolt that was to lead to the experiment of the Commune broke out in Paris.

● In 1874 the first exhibition of Impressionist painters was held in the photographer Nadar's studio. Manet did not exhibit with the group but was regarded as their charismatic leader. Gustave Courbet, one of the principle sources of inspiration for Manet's work of aesthetic renewal, died in 1877.

● In 1878 Manet illustrated Edgar Allan Poe's *Annabel Lee*, translated by Mallarmé, and was awarded the Legion of Honour. He died in 1883 after undergoing the amputation of a leg.a

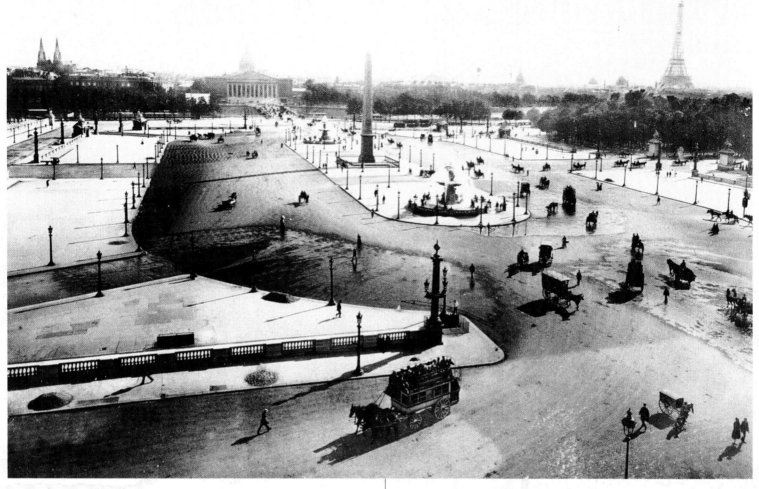

◆ **PLACE DE LA CONCORDE**
Great squares and spacious boulevards were the result of the gutting of the medieval fabric of Paris carried out by the prefect Haussmann. The city thus assumed the characteristics of the *ville des lumières* portrayed by Manet.

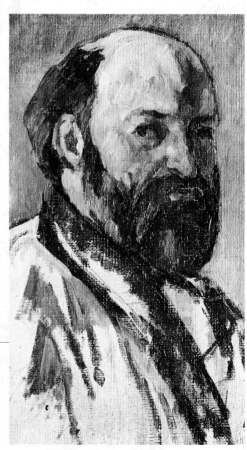

◆ PAUL CÉZANNE
*Self-portrait at the Age of Forty*
(1880-81, Paris, Musée d'Orsay)
The artistic career of Paul Cézanne, born a few years after Manet, was marked just like the master's by the constant hostility of the critics. It was not until some decades later that his genius was to be celebrated by the Cubists.

# THE HERITAGE OF MANET
# A NEW PICTORIAL CULTURE

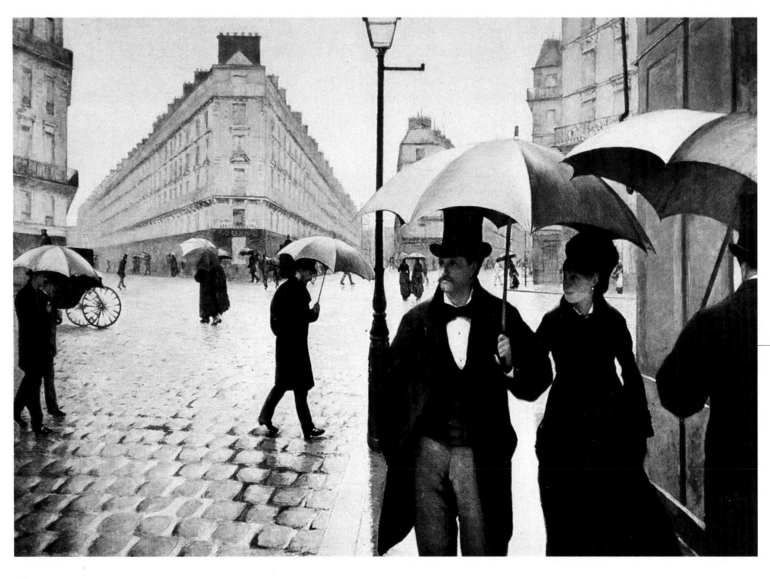

Edouard Manet is often – and erroneously – regarded as an Impressionist painter, but it was only towards the end of his career that he was to draw closer to the work of the *plein air* painters. It is, however, possible to regard his work in the light of his repeated contacts with the Impressionist group as heralding a renewal of artistic culture that reached its peak with them, and to trace a definite relationship between his work and each member of the new group. One of those closest to Manet was Edgar Degas, perhaps the most independent of the group, who did most to absorb and develop the master's teaching. A painter of figures rather than landscapes, he pursued his deep and sophisticated explorations parallel to Monet, who followed Manet in his reinterpretation of painting through the speed of vision, and Renoir, who achieved renewal through his effortless style. With Bazille and later Caillebotte, Manet's teaching attained an almost metaphysical level of realistic simplification.

● Later on, Manet was to inspire the canvases of illustrious successors, who saw his work as the birth of modern art. From Matisse to Picasso, who dedicated a *Déjeuner* of his own to Manet in 1961, Manet's intense output was the source of the impassioned explorations conducted at the turn of the century by the School of Paris.

◆ FREDERIC BAZILLE
*The Artist's Family*
(1868-1869, Paris,
Musée d'Orsay)
Bazille, who died at a
very early age in the
Franco-Prussian War,
was one of Manet's most
illustrious successors.

◆ EDGAR DEGAS
*The Belelli Family*
(1858-1860,
Paris, Musée d'Orsay)
Painted during
a stay in Florence,
this work documents
the influence
of Manet filtered
through acute
psychological analysis.

◆ PABLO PICASSO
*Le Déjeuner sur l'herbe*
(1961, Paris,
Lairis Gallery)
Picasso's homage
to Manet's work
brings a canvas
that marked a turning
point in the history
of painting into
the contemporary
sphere. The scene
seems to take place
in the realm
of dreams.
The figures seem
to float in space,
charging the image
with ambiguous
meanings that flicker
around the universe
of the subconscious.

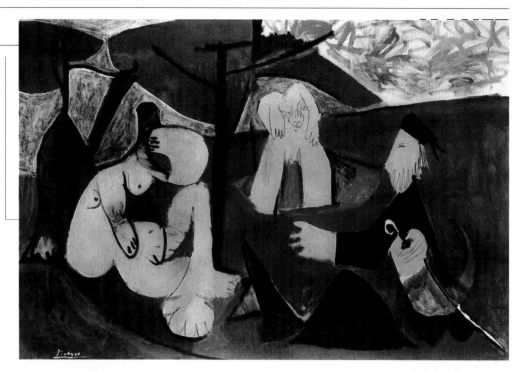

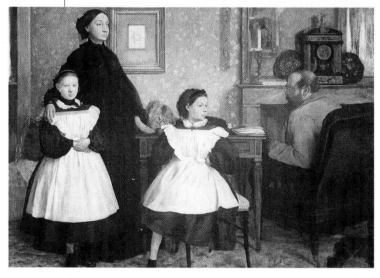

◆ CLAUDE MONET
*Le Déjeuner sur l'herbe*
(1865, Paris,
Musée d'Orsay)
Monet's
enormous
canvas includes
eleven figures.
The artist not
only drew his
subject from
Manet, but also
reworked it in
pictorial terms
through the
felicitous
application of the
Impressionists'
*plein air* technique.

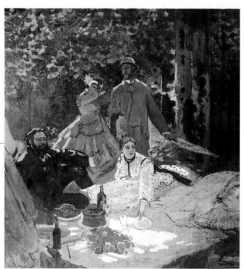

◆ GUSTAVE
CAILLEBOTTE
*Paris Street,
Rainy Day*
(1877, Chicago,
Art Institute)
A collector and
admirer of the
Impressionists,
Caillebotte went beyond
Manet's conception
of realism to endow
the image of this
canvas with a timeless
dimension accentuated
by the extremely
rigorous application
of perspective.

◆ AUGUSTE RENOIR
*Madame Monet
Reading*
(1874, Lisbon,
Fundaçao
Calouste Gulbenkian)
Renoir captures
Madame Manet
in a moment
of repose. The
pose resembles
that of Manet's
portrait of his
wife reclining
on a sofa, which
was executed
in the same period.
Instead of the
master's flat
surfaces, however,
Renoir uses lively,
vigorous brushstrokes
that endow
the work with
sparkling vitality.

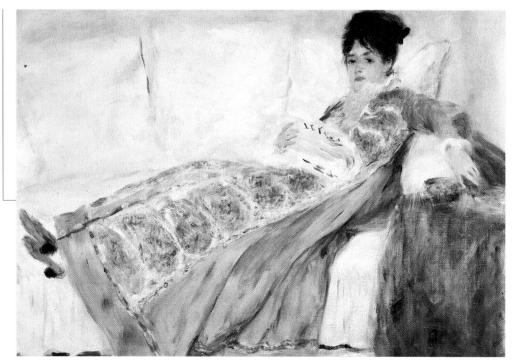

# THE ARTISTIC JOURNEY

For a vision of the whole of Manet's production, we propose here a chronological reading of his principal works.

### ◆ THE BOY WITH CHERRIES (1858)

The figure emerges from a dark background, but examination of the details of the face and hand reveals the same handling of light to be found later in *The Fifer* (1866). The boy, who worked in Manet's studio, was subject to fits of depression. One evening the painter discovered his body in a corner where he had hanged himself.

### ◆ CONCERT IN THE TUILERIES GARDENS (1862)

This is Manet's first work with a modern subject, a portrait of the crowd in the Paris of the Second Empire. The canvas is characterized by the dandified, sophisticated spirit with which the artist observes the society to which he himself belongs. The figures taking the air beneath the trees include the poet Baudelaire and numerous contemporary artists and personages.

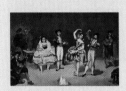

### ◆ THE SPANISH DANCERS (1862)

The arrival of a company of Spanish dancers in Paris in 1862 was a source of profound artistic inspiration for Manet, who interprets the scene with great realism combined with a taste for the exotic. For the approach adopted and the range of colors employed, some critics regard this as his freshest and most modern work.

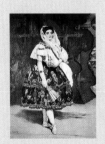

### ◆ LOLA DE VALENCE (1862)

Portrait of the prima ballerina of the Spanish company performing in Paris. Baudelaire's accompanying verses testify to the success of the work with the master's admirers. Lola dominates the scene, full of self-confidence and smiling ambiguously. Her pose derives from Goya and a lithograph by Daumier. Manet was to produce other canvases inspired by the theatre, which Degas admired intensely.

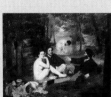

### ◆ LE DÉJEUNER SUR L'HERBE (1863)

Inspired by Giorgione's *Concert Champêtre* and Raphael's *Judgement of Paris*, this work caused an outcry both for its subject and for its technique. The nude and the still life are rendered with great freshness and embedded perfectly into the landscape. This synthesis – a problem that had remained unsolved for many years in French painting before Manet – is the work's most important achievement.

### ◆ OLYMPIA (1863)

This canvas, which recalls Titian's *Venus of Urbino*, is one of the masterpieces of modern painting. The white of the naked body is emphasized still further by the dark skin of the maid, the brightly colored flowers and the black cat. The subject caused great indignation, and two attendants were posted to guard the painting and make sure that the public did not attack and destroy it.

### ◆ CHRIST WITH ANGELS (1864)

This painting again caused an outcry. The choice of a religious subject was highly unusual for the period and has no connection with the painter's own principal interests. The public did not like this Christ with "dirty black shadows". The work is influenced by the tradition of Spanish painting, with funereal blacks and whites interrupted by browns and blues. Zola alone was to defend the work.

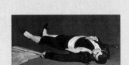

### ◆ THE DEAD TOREADOR (1864)

This work was initially part of a large single canvas entitled *Episode from a Bullfight*, but Manet was dissatisfied with the painting and divided it into two parts. Although the body is somewhat wooden and stiff, the harmony of the colors makes the work great. The old-rose tints of the cape and the range of blacks emerging from the dark olive-green background demonstrate Manet's expert handling of color.

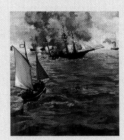

### ◆ NAVAL BATTLE BETWEEN THE KEARSAGE AND THE ALABAMA (1864)

This is one of the few historical subjects painted by Manet, who may have witnessed this episode of the War of Succession. On 19 June 1864, off Cherbourg, a corvette of the United States Federal Navy attacked the *Alabama*, a pirate ship of the Confederate South. The real subjects of this painting are the sea and the sky, the battle between the waves, the smoke and the clouds.

### ◆ STILL LIFE WITH FISH AND OYSTERS (1864)

In Manet's still lifes, objects assume the same importance as human figures. Here the artist portrays the silvery scales and belly of the rosy-headed fish with great realism. The oysters lend the canvas a fashionable air and add a touch of freshness. The bright hues of the lemon contrast with the grays and blacks.

### ◆ THE RACES AT LONGCHAMP (1864)

In 1864 Manet frequented the racetracks for a short period. This work paved the way for many generations of later painters. The movement of the race is rendered with quick brushstrokes that capture the horses and jockeys on canvas as they flash by. The dynamic effect is such that they seem about to burst out of the canvas and trample the viewer.

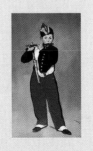

### ◆ THE FIFER (1866)

Here, for the first time, Manet chooses to immerse the subject in a light diffused over the entire surface of the canvas. The fifer, portrayed frontally, stands out triumphantly against a luminous background. Nevertheless, the work was accused of flatness and described as a painting of foot soldiers pinned on a door. Its monumental simplicity, which now fascinates us, was then found offensive by traditionalists.

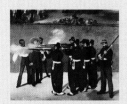

### ◆ THE EXECUTION OF EMPEROR MAXIMILIAN OF MEXICO (1867)

On 19 June 1867, the Emperor Maximilian of Mexico was executed by firing squad. The political character of the painting made it impossible to exhibit it at the exhibition at Place d'Alma for reasons of public order. The work is strongly influenced by Goya's *The 3rd of May 1808: the Execution of the Defenders of Madrid*, but with no sense of civil participation.

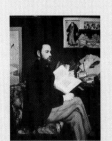

### ◆ PORTRAIT OF EMILE ZOLA (1868)

Painted by Manet as a token of gratitude for his friend's favorable reviews, this work is important for the handling of characterization. The figure stands out against the flat areas of color. Manet's interest in Japanese art can be seen in the smooth modulation of form and in details such as the screen and the Utamaro print on the wall.

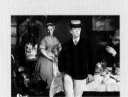

### ◆ LUNCHEON IN THE STUDIO (1868)

In the summer of 1868, Manet spent six weeks at Boulogne-sur-mer in the furnished apartment of an old sailor, and painted a sketch of the dining room. On his return to Paris he resumed work on the subject and called the result *Le déjeuner*. When it was presented at the Salon of 1869, the critics recognized qualities such as the "harmony of very powerful shades of grey", but were not impressed.

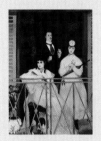

### ◆ THE BALCONY (1868)

The three figures in the foreground are the landscape-painter Antoine Guillemet, the violinist Fanny Claus and Berthe Morisot. Leon Koella appears behind them carrying a tray. The work, presented at the Salon of 1869, was a success. The figures are expertly characterized, but remain peculiarly isolated from one another and mutually extraneous. The light hues are rendered with great delicacy.

### ◆ PORTRAIT OF BERTHE MORISOT WITH A BUNCH OF VOILETS (1872)

Portrayed here in a canvas of remarkable synthesis, Berthe Morisot was a young pupil of Corot who later joined the group of Impressionists. Manet painted several portraits of her, and their friendship turned into a family tie when she married his brother.

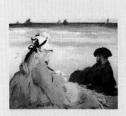

### ◆ ON THE BEACH (1873)

This painting depicts Manet's wife and brother at Beck-sur-mer in the summer of 1873, and displays more than any other the master's sensitive handling of color. The black ribbon of the hat and the grayish-blue hues tone down the luminosity of the canvas and highlight the figures in the foreground. As Jacques de Biez said of Manet, "He lived only to realize the idea he had inside him, the idea of light."

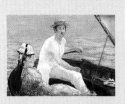

### ◆ THE COUPLE IN A SAILING BOAT (1874)

There are three elements making it possible to classify this as an authentic Impressionist work: the *plein air* painting technique, which lends vivacity to the colors, the high viewpoint adopted, making the background indefinite and rather flat, and the choice of a scene of modern life drawn from one of the fashionable pastimes that Manet enjoyed.

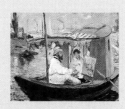

### ◆ MONET AND HIS WIFE IN HIS FLOATING STUDIO (1874)

Due to financial difficulties, Monet rented a boat at Argenteuil and turned it into his studio. Manet painted his friend in the boat with his wife. This is one of the very first works to be painted *en plein air*. The vibrant brushstrokes – sometimes combining as many as three different shades of color – lend an air of softness and vivacity to the scene as a whole.

### ◆ PORTRAIT OF STEPHANE MALLARMÉ (1873)

Like the portrait of Emile Zola, this work was again the result of close friendship between the two artists. But while the former is devoid of all emotional tension, here Manet sought to capture the psychological character of his subject, and the hands express tension. The poet is portrayed with raised eyebrows, reclining in an armchair, totally absorbed in profound meditation.

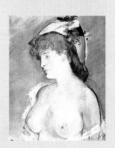

### ◆ NANA (1877)

This work was displayed in the shop window of Maison Giroux after its refusal by the Salon. Nana is shown painting her lips in a bodice of blue silk, semi-transparent underskirt and grayish-blue stockings. She appears to be listening to the gentleman waiting for her in evening dress just inside the painting, which was judged "vulgar". A Japanese-style crane can be seen against the luminous background.

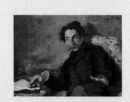

### ◆ THE BLONDE WITH BARE BREASTS (1878)

Manet was unquestionably a great painter of female figures and nudes. The model portrayed her was named Marguerite. The hues of her complexion are superb and the mother-of-pearl nuances of the skin stand out even more against the green background. The whole figure is bathed in light and the nude is lent its particular quality by a few brushstrokes of white and red ochre.

### ◆ FLAGS IN RUE MOSNIER (1878)

To celebrate the Universal Exposition, the 30th of June 1878 was declared a national holiday and flags were flown everywhere. Manet observed the display from his studio window and sought above all to capture the rich profusion of colors. The work is largely influenced by Impressionism both in its subject matter and in its range of color.

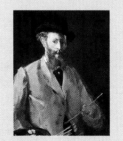

### ◆ SELF-PORTRAIT WITH PALETTE (1879)

Manet was 47 when he portrayed himself with great irony putting the finishing touches of color to his yellow jacket. Looking at himself in the mirror, he did not bother to correct his reflected image and we thus see him painting with his left hand. The eye depicted in full light indicates his determined character. As in the portrait of Mallarmé, the hand betrays a certain emotional tension.

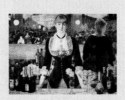

### ◆ BAR AT THE FOLIES-BERGÈRE (1881-82)

This is the last important work by Manet, already weakened by illness. The glow of the colors and the gaslights reflected in the mirror, the glassware and the bottles on the marble counter create an almost unreal atmosphere expressing the ephemeral pleasure of the night. The young blonde is facing a customer reflected in the mirror but playfully kept out of the painting.

# TO KNOW MORE

The following pages contain: some documents useful for understanding different aspects of Manet's life and work;
the fundamental stages in the life of the artist; technical data
and the location of the principal works found in this volume; an essential bibliography.

## DOCUMENTS AND TESTIMONIES

## Illustrious opinions

*Manet was often accused of copying Spanish art. His great friend the writer Charles Baudelaire took a different view.*

"Dear Sir, I don't know if you remember me and our discussions in the old days. The years pass so quickly! I read what you write assiduously and wish to thank you for the pleasure you gave me by defending my friend Edouard Manet and doing him justice. In the opinions you expressed, there are, however, a few small points that need correction.

Manet, who people consider a raving lunatic, is a very loyal and straightforward man who does his utmost to be reasonable. To his misfortune, he has, however, been steeped since birth in Romanticism. The term "imitation" is not appropriate. Manet has never seen anything by Goya; Manet has never seen anything by El Greco; Manet has never seen the Pourtalés Gallery. You will find this incredible, but it is true. I too am amazed at these mysterious coincidences.

In the period when we enjoyed the use of that wonderful Spanish museum that the idiotic French Republic has, in its misguided respect for ownership, restored to the princes of Orléans, Manet was serving on a ship. He has been told so much about his imitations of Goya that he is now trying to see some Goyas.

It is true that he has seen some Velázquez, but I don't know where. Do you doubt my words? Do you doubt that such bewildering geometric parallels can occur in nature? Well, I am accused of imitating Edgar Allan Poe, but do you know why I have studied Poe with such patience? Because of his similarity to me. [...]"

[C. Baudelaire, letter to Thoré-Burger, 7 May 1864]

*The writer Emile Zola was another great friend and champion of Manet. He was very surprised at the failure of some critics and sections of the public to understand Manet's work.*

"Manet's place in the Louvre is reserved, as is that of Courbet and every artist of strong and unyielding temperament [...]. I have tried to give to Manet the place he merits, one of the highest. People may laugh at the 'panegyrist' as they laughed at the painter. One day we shall both be vindicated. There is an eternal truth that sustains me with regard to criticism, that only temperaments live and dominate time. It is impossible, you understand, quite impossible for Manet not to triumph, crushing the timid nonentities that surround him [...]."

[E. Zola in *Evénement illustre*, 10 May 1866]

**Manet in a celebrated photograph**

## The Poet of Modernity

*This piece by Antonin Proust, a profound connoisseur of Manet's work deeply, gives a very clear idea of how the painter sought to capture reality, the fleeting moment or rather impression.*

"In Manet the eye played such a large part that Paris has never known anyone to stroll about quite as much as him, or as usefully. When the winter days arrived and masked the light from the morning on so that no painting was possible in the studio, we would pack up and head for the suburban avenues. There he would sketch some trifle in his notebook, a profile, a hat, in short a fleeting impression. And when, the following day, a friend thumbed through the notebook and said, "You should finish this," he was doubled up with laughter. "You take me for a history painter," he would say. For him, "history painter" was the worst insult possible for an artist."

[A. Proust, in "Revue blanche", 1 February 1897]

"There is nothing in Manet but good painting. He could have lived to eighty without anyone recognizing his merit."

[George Moore, 1878]

## Against all censorship

*This piece by Zola testifies to the state of crisis affecting the reign of Napoleon III. The emperor was losing authority and power due to a series of political and military failures, including the outbreak of the Mexican revolution. This led to the execution of Maximilian of Austria, depicted by Manet in a painting.*

"I read in the latest issue of "La Tribune" that they have refused to print a lithograph of Manet's execution of Maximilian [...].
Is the ruling class therefore so sick that its servants wish to spare it the slightest upset?
The censors certainly thought: "If we allow Maximilian to be executed in public, his shade will blight the corridors of the Tuileries like some sinister plant [...]."
I am well aware of the sort of lithograph these gentlemen would like, and advise Monsieur Manet, if he wishes to find favor with them, to portray Maximilian full with life, walking alongside his wife, smiling and happy [...]."

[E. Zola, "Coups d'épingles"
in "La Tribune", 4 February 1869]

# HIS LIFE IN BRIEF

**1832.** Edouard Manet was born on 23 January in Paris. His father August was chief of personnel at the Ministry of Justice and his mother, Eugénie-Desirée Fournier, the daughter of a diplomat serving in Stockholm.

**1839-45.** Started school in Vaugirard but was enrolled shortly afterwards at the Collège Rollin, where he met Antonin Proust.

**1848.** Having finished his studies at the Collège Rollin, he refused to study law and joined the navy. Embarked on a transport vessel as an apprentice pilot.

**1850.** Started painting in the studio of Thomas Couture.

**1853.** Journey to Italy.

**1858.** Painted the *Absinthe Drinker*. Couture criticized him bitterly and they broke off relations.

**1860.** Painted the *Concert in the Tuileries Gardens*, which was greeted enthusiastically by his friends, including Baudelaire.

**1861.** The *Spanish Singer* was accepted at the Salon.

**1862.** A troupe of Spanish dancers provided the inspiration for *Spanish Dancers* and *Lola de Valence*. Manet's father died, leaving him a fortune that he proved incapable of managing.

**1863.** *Le Déjeuner sur l'herbe* caused a great scandal. Painted *Olympia*.

**1864.** The naval engagement between the *Kearsage* and the *Alabama* inspired him to paint a highly successful work.

**1865.** Exhibited *Olympia* at the Salon, giving rise to great controversy.

**1867.** The year of the Universal Exposition. Manet's works were not exhibited despite Zola's impassioned advocacy. Death of Baudelaire.

**1871.** Returned to Paris after its surrender and discovered that he had been elected to the Commune's federation of artists.

**1873.** Exhibited *Le Bon Bock* at the Salon to great acclaim.

**1876.** The first signs of ataxia.

**1877.** Began painting naturalistic works such as *Nana*.

**1878.** Decided to exhibit his works only in the studio, refusing to present them at either the Universal Exposition or the Salon.

**1881.** Concentrated primarily on portraits of friends and particular characters in oil and pastel.

**1882.** Exhibited *Bar at the Folies-Bergère* at the Salon to great acclaim. Painted above all still lifes and portraits of women on horseback.

**1883.** Died on 30 April. On 3 May A. Proust delivered the funeral oration.

# WHERE TO SEE MANET

*The following is a listing of the technical data for the principal works of Manet that are conserved in public collections. The list of works follows the alphabetical order of the cities in which they are found. The data contain the following elements: title, dating, technique and support, size expressed in centimeters.*

HAMBURG (GERMANY)
**Jean Baptiste Faure as Hamlet**, 1877; oil on canvas, 196x130; Kunsthalle.

**Nana**, 1877; oil on canvas, 150x116; Kunsthalle.

**Portrait of Henri Rouchefort**, 1881; oil on canvas, 81.5x66.5; Kunsthalle.

BERLIN (GERMANY)
**In the Wintergarden**, 1879; oil on canvas, 115x150; Staatliche Museen.

**The Villa at Reuil**, 1882; oil on canvas, 73x92; Staatliche Museen.

BOSTON (UNITED STATES)
**Strolling Musician**, 1862; oil on canvas, 179x109; Museum of Fine Arts.

BREMEN (GERMANY)
**Portrait of Zacharie Astruc**, 1864; oil on canvas, 90x116; Kunsthalle.

CHICAGO (UNITED STATES)
**The Races at Longchamp**, 1864; oil on canvas, 43x83; Art Institute.

**Still life with Fish and Oysters**, 1864; oil on canvas, 73x92; Art Institute.

COPENHAGEN (DENMARK)
**The Absinthe Drinker**, 1858; oil on canvas, 181x106; Ny Carlsberg Glyptothek.

**The Execution of the Emperor Maximilian of Mexico**, 1867; oil on canvas, 50x61; Ny Carlsberg Glyptothek.

DIJON (FRANCE)
**Portrait of Suzon**, 1881; oil on canvas, 54x34; Musée des Beaux-Arts.

PHILADELPHIA (UNITED STATES)
**The Kearsage and the Alabama**, 1864; oil on canvas, 145x130; J.J. Johnson Collection.

LISBON (PORTUGAL)
**Boy Blowing Soap Bubbles**, 1867; oil on canvas, 100x81.4; Fundaçao Calouste Gulbenkian.

LONDON (GREAT BRITAIN)
**Concert in the Tuileries Gardens**, 1860-62; oil on canvas, 76x118; National Gallery.

**Bar at the Folies-Bergère**, 1881; oil on canvas, 96x130, Courtauld Institute.

MANNHEIM (GERMANY)
**The Execution of the Emperor Maximilian of Mexico**, 1867; oil on canvas, 195x259; Kunsthalle.

MUNICH (GERMANY)
**Luncheon in the Studio**, 1868; oil on canvas, 120x154; Bayerische Staatsgemäldesammlungen.

**Monet with his Wife in his Floating Studio**, 1874; oil on canvas, 80x98; Neue Pinakothek.

NEW YORK (UNITED STATES)
**The Spanish Singer**, 1860; oil on canvas, 146x114, Museum of Modern Art.

**Christ with Angels**, 1864; oil on canvas, 175x155, Museum of Modern Art.

**Woman with Parrot**, 1866; oil on canvas, 185x132, Museum of Modern Art.

**Couple in Sailing Boat**, 1874; oil on canvas, 96x130, Museum of Modern Art.

PARIS - MUSÉE D'ORSAY (FRANCE)
**Lola de Valence**, 1862; oil on canvas, 123x92.

**Le déjeuner sur l'herbe – Luncheon on the Grass**, 1863; oil on canvas, 214x270.

**Olympia**, 1863; oil on canvas, 130x190.

**The Fifer**, 1856; oil on canvas, 164x97.

**The Balcony**, 1868; oil on canvas, 170x124.5.

**Portrait of Emile Zola**, 1868; oil on canvas, 146x114.

**The Reading**, 1868; oil on canvas, 60.5x73.5.

**On the Beach**, 1873; oil on canvas, 57x72.

**Blonde with Bare Breasts**, 1878; oil on canvas, 62x51.

**Lady with Fans**, 1874; oil on canvas, 113.5x166.5.

**La Serveuse de Bocks**, 1879; oil on canvas, 77.5x65.

**Irma Brunner in a Pink Corset**, 1882; pastel, 55.5x46.

TOURNAI (FRANCE)
**Argenteuil**, 1874; oil on canvas, 149x131; Musée des Beaux Arts.

WASHINGTON (UNITED STATES)
**The Spanish Dancers**, 1860; oil on canvas, 146x114; The Phillips Memorial Gallery.

**Old Musician and Bystanders**, 1862; oil on canvas, 188x248; National Gallery of Art.

**The Dead Toreador**, 1864; oil on canvas, 75x153; National Gallery of Art.

**The Railroad**, 1873; oil on canvas, 93x112; National Gallery of Art.

UPPERVILLE (UNITED STATES)
**Rue Mosnier, Paris**, 1878; oil on canvas, 65x80; Mellon Collection.

WINTHERTUR (SWITZERLAND)
**At the Café-Concert**, 1878; oil on canvas, 46x38; O. Reinhart am Roemerholz Collection.

ZURICH (SWITZERLAND)
**The Harbour at Bordeaux**, 1871; oil on canvas, 63x100, Buhrle Collection.

# BIBLIOGRAPHY

The following list furnishes some guides useful for obtaining the first instruments of orientation and information on the artist.

1866   E. Zola, "Mon Salon. M. Manet", *L'Evénement*, 7 mai.

1884   E. Bazire, *Manet*, Paris.

1895   G. De Nittis, *Notes et souvenirs*, Paris

1902   H. Von Tschudi, *Edouard Manet*, Berlin.

1913   A. Proust, *Edouard Manet, Souvenirs*, Paris.

1926   E. Moreau-Nélaton, *Manet raconté par lui même*, Paris.

1932   P. Valéry, *Le triomphe de Manet*, Paris.

G. Bazin, "Manet et la tradition", *L'Amour de l'Art, XIII*, pp. 153-64.

1945   P. Courthion, *Manet raconté par lui même et par ses amis*, Geneva.

1947   A. Tabarant, *Manet et ses oeuvres*, Paris.

1948   J. Leymarie, *Manet et les impressionistes au musée du Louvre*, Paris.

1951   J. Leymarie, *Edouard Manet*, Paris.

1955   G. Bataille, *Manet*, Geneva.

1958   J. Richardson, *Edouard Manet*, Paris.

1962   Courthion, *Manet*, Milano.

1966   A. Coffin Hanson, *Edouard Manet 1832-1883*, Philadelphia, exhibition catalogue.

1967   S. Orienti, *L'opera pittorica di E. Manet*, (introduction by M. Venturi), Milano.

1968   Harris, Isaacson, *Manet and Spain, prints and drawings*, Michigan.

1972   A. C. Hanson, "Popular imagery and the work of Edouard Manet", in *French 19th Century Painting and Literature*, pp. 133-63, Manchester.

1976   J. Rewald, *The History of Impressionism*, New York.

1977   A. C. Hanson, *Manet and the modern tradition*, New Haven and London.

1980   C. L. Cahan, *Manet*, New York.

1983   A. Coffin Hanson, F. Cachin, C.S. Moffett, M. Melot, *Manet*, Paris, exhibition catalogue.

1988   T. A. Gronberg, *Manet. A retrospective*, New York.

J. W. Bareau, *Edouard Manet, Voyage en Espagne*, Caen.

1994   H. Loyret, G. Tinterow, *Impressionisme: Les origines 1859-1869*, Paris, exhibition catalogue.

Chagall
One Hundred Paintings
The Falling Angel

Dali
One Hundred Paintings
The Persistence of Memory

Kandinsky
One Hundred Paintings
The First Abstract Watercolour Painting

Leonardo
One Hundred Paintings
The Last Supper

Manet
One Hundred Paintings
Le déjeuner sur l'herbe

# ONE HUNDRED PAINTINGS:

## every one a masterpiece

The Work of Art. Which one would it be?
...It is of the works that everyone of you has in mind that I will speak of in "One Hundred Paintings". Together we will analyse the works with regard to the history, the technique, and the hidden aspects in order to discover all that is required to create a particular painting and to produce an artist in general.

It is a way of coming to understand the sensibility and personality of the creator and the tastes, inclinations and symbolisms of the age. The task of "One Hundred Paintings" will therefore be to uncover, together with you, these meanings, to resurrect them from oblivion or to decipher them if they are not immediately perceivable. A painting by Raffaello and one by Picasso have different codes of reading determined not only by the personality of each of the two artists but also the belonging to a different society that have left their unmistakable mark on the work of art. Both paintings impact our senses with force. Our eyes are blinded by the light, by the colour, by the beauty of style, by the glancing look of a character or by the serenity of all of this as a whole. The mind asks itself about the motivations that have led to the works' execution and it tries to grasp all the meanings or messages that the work of art contains.

"One Hundred Paintings" will become your personal collection. From every painting that we analyse you will discover aspects that you had ignored but that instead complete to make the work of art a masterpiece.

Federico Zeri

## Coming next in the series:

**Matisse, Magritte, Titian, Degas, Vermeer, Schiele, Klimt, Poussin, Botticelli, Fussli, Munch, Bocklin, Pontormo, Modigliani, Toulouse-Lautrec, Bosch, Watteau, Arcimboldi, Cezanne, Redon**

Raphael
One Hundred Paintings
School of Athens

Rembrandt
One Hundred Paintings
Supper at Emmaus

Renoir
One Hundred Paintings
Moulin de la Galette

Rubens
One Hundred Paintings
Garden of Love

Van Gogh
One Hundred Paintings
Starry Night